Nature Photography
HOTSPOTS

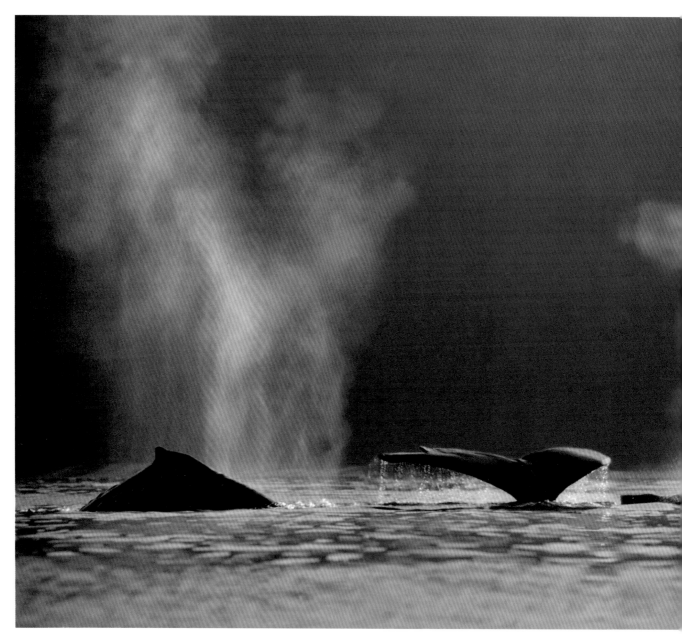

Humpback Whales, Alaska

Nature Photography
HOTSPOTS

Where to Find Them • When They're at Their Best • How to Approach Them

Text and Photographs by
Tim Fitzharris

FIREFLY BOOKS

A Firefly Book

Cataloguing in Publication Data
Fitzharris, Tim, 1948—
 Nature Photography Hotspots

Includes bibliographical references.
ISBN 1-55209 092-2
1. Nature photography. I. Title.
TR721.F575 1997 778.9'3 C96—931984-3

Produced by Terrapin Books

Project Supervisor: Joy Sambilad-Fitzharris
Design Director: Klaus van Tyne
Research: Jocelyn Delan

Published by Firefly Books

Firefly Books
3680 Victoria Park Avenue
Willowdale, Ontario
Canada M2H 3K1

Firefly Books (U.S.) Inc.
P.O. Box 1338
Ellicott Station
Buffalo, New York 14205

Printed in Hong Kong

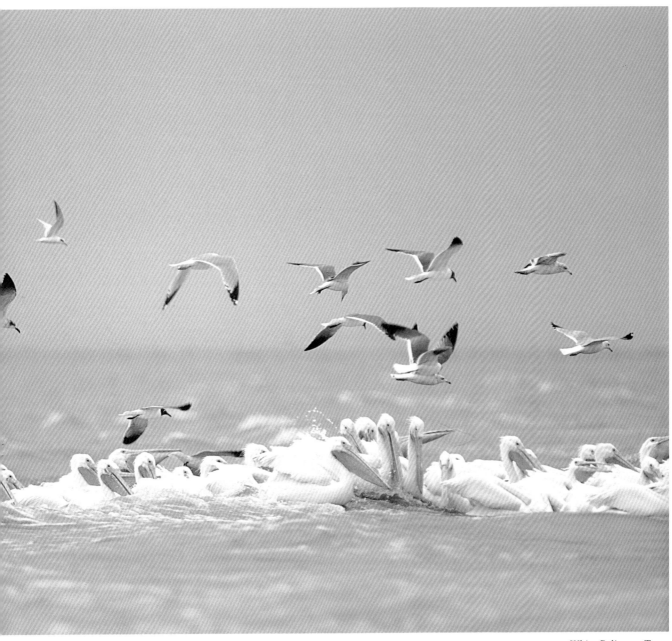

White Pelicans, Texas

Surfacing Hippopotamus, Kenya

Other Books by Tim Fitzharris

The Sierra Club Guide to Close-up Photography in Nature

Wild Bird Photography: National Audubon Society Guide

Nature Photography: National Audubon Society Guide

Fields of Dreams: Travels in the Wildflower Meadows of America

Soaring with Ravens: Visions of the Native American Landscape

The Sierra Club Guide to 35 mm Landscape Photography (New Edition)

Coastal Wildlife of British Columbia (written by Bruce Obee)

Wild Wings: An Introduction to Birdwatching

Forest: A National Audubon Society Book

Wild Birds of Canada

Canada: A Natural History (with writer John Livingston)

British Columbia Wild

Wildflowers of Canada (with writer Audrey Fraggalosch)

The Wild Prairie: A Natural History of the Western Plains

The Adventure of Nature Photography

The Island: A Natural History of Vancouver Island

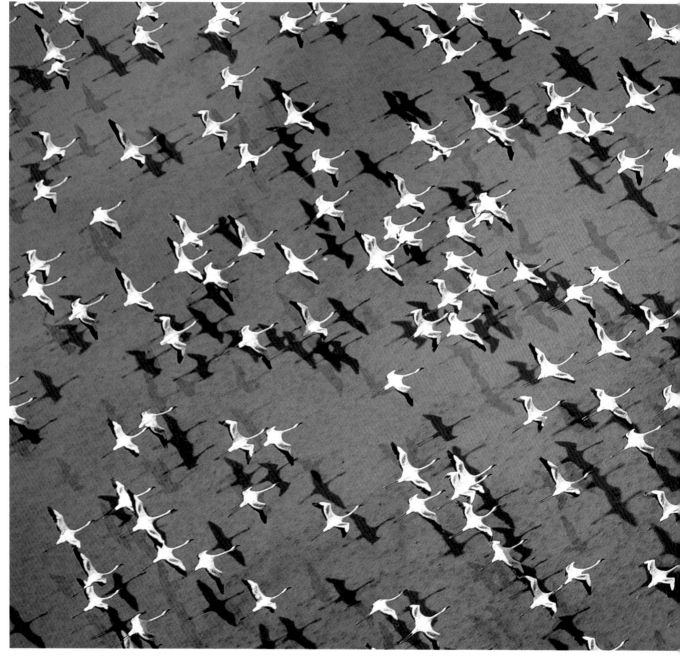

Lesser Flamingos, Kenya

Contents

Introduction

With Camera Aimed at the Horizon

THE JEEP WAS UNDETERRED by the string of potholes that distinguished the narrow trail from the sweep of savannah. Its suspension passed along the expected bruising of African travel to me and Daniel, the Maasai who guided me about his neighborhood.

Cold, mute, and half asleep, we lurched doggedly eastward toward the coming dawn and a meandering river of wildebeest. My spirits would rise with the first spill of warm light over the edge of the earth. It would illuminate the wildebeest and signal the beginning of photography—my reward for this predawn sacrifice.

I braked hard and leaped out. Under Daniel's widening gaze, I began to gather pebbles. Every moment was precious and in a wink I was lying flat with camera aimed at the horizon. I steadied the long lens on the small pile of rocks, fumbling until the scene was positioned in the view-finder. I took an exposure reading off the sky and began shooting. The image formed, magical and unexpected: a giraffe in silhouette against an abstract expanse of bronze. Suddenly I was awake, loving this early morning foray.

Such adventures are commonplace for anyone who photographs nature, an undertaking which marries artistic endeavor with an appreciation of wilderness and wildlife. This book identifies 30 special locations for photography. Some may be familiar to you already. Others, which I discovered by chance, will likely be unknown. All of them offer abundant wild subjects that can be approached readily. In some cases the sites are of international ecological significance.

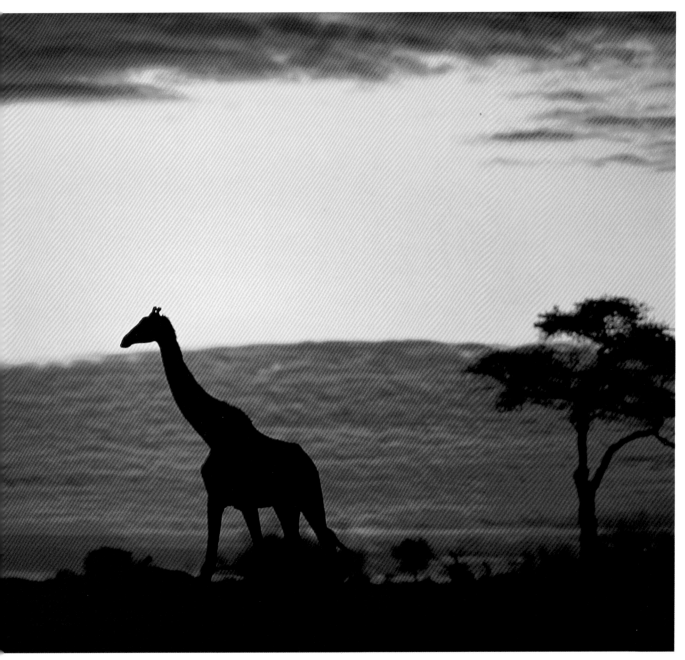

Maasai Giraffe, Kenya

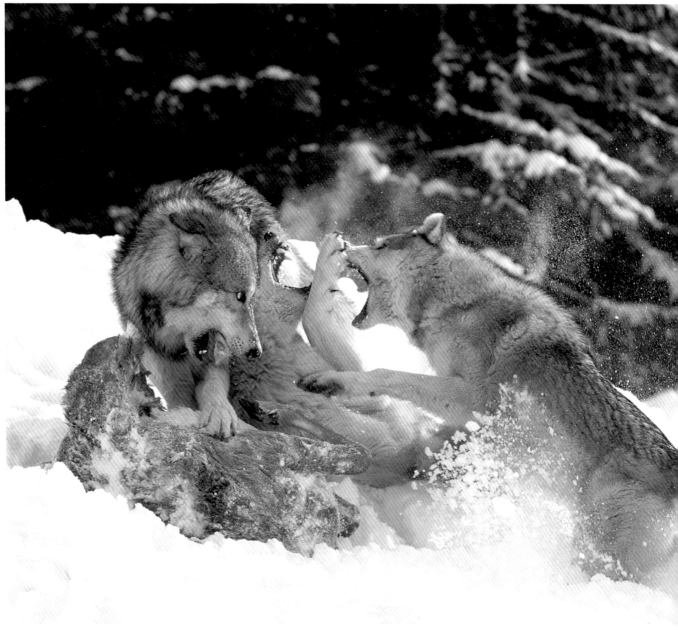

Gray Wolves, Montana

This book is intended for serious photographers who enjoy traveling in remote areas. The text describes the type of pictures you can expect to make and guides your photographic efforts while on location. Valuable information is provided on how to reach each site and to accommodate yourself while shooting. Before setting out for any of these hotspots, especially those in the Third World, consult an appro-priate regional travel guide (see the appendix for recommended guides). You can journey to all of these locations independently, work according to your personal schedule, and pursue your own photo-graphic goals—all at a cost considerably less than an organized tour. There will be extra work arranging the trip yourself, and perhaps some added anxiety (or added adventure) carrying it out. But the free-dom to work when, where, and how you wish and the knowledge that your images will be unique compensate for these drawbacks.

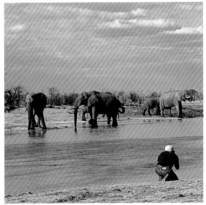

Productive photography is almost assured at all of the hotspots described. But keep in mind that circumstancs do not remain the same forever: droughts happen, migration patterns shift, government regula-tions change. So call ahead before you schedule an expedition to check out current conditions. Success at some of the locations requires a professional approach (such as using blinds). If you are not familiar with advanced nature pho-tography techniques, study the photography guide books listed in the appendix. Take careful note of the shooting strategies described for each location. They provide valuable tips specific to the problems you will encounter.

Although each hotspot is identified by one or two subjects (such as humpback whales, hummingbirds and columbines, or white pelicans), all have been selected be-cause they provide good opportunities for photographing a number of other subjects found in the area.

It is rare to meet a nature photographer who does not have deep concern about the accelerating deterioration of the earth's environment—about the loss of natural habitats to spreading industrialism and increasing human populations. Bringing atten-tion to the plight that wild ecosystems face through photography is an effective way to gain public support for environmental causes. Share your enthusiasm, your work, and your philosophy with others.

Good shooting and safe travels!

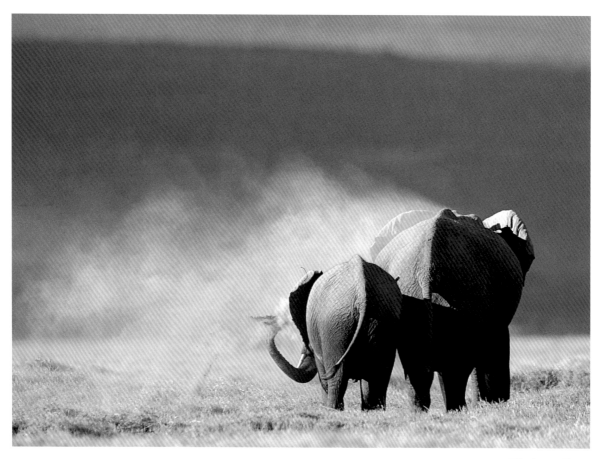

Elephants, Kenya

Marine Wildlife

Orca Pods

Johnstone Strait, Vancouver Island • August

The best time to attempt whale photography is in the early morning when the waters of Johnstone Strait are most likely to be calm. This picture was taken just outside the entrance to Telegraph Cove harbor. I used a Cokin 2-stop graduated, neutral density filter to darken the sky and retain its rich color. Canon EOS A2, 28-105 mm Canon lens set at about 80 mm, Fujichrome Velvia, f/4.5 at 1/60 second.

THERE IS NO MORE dependable location to photograph pods of killer whales than Johnstone Strait, lying between the British Columbia mainland and northern Vancouver Island. Not only is the area inhabited by resident pods, but it is also a gathering place for transient whales at certain times of the year. Whales are attracted by salmon which gather in August at the mouths of streams and rivers before heading inland to spawn. Whales also frequent Robson Bight, a shallow inlet where

they convene in the shallows to rub their bellies on the pebble bottom.

The resident whales in Johnstone Strait feed primarily on fish, while the transient pods tend to hunt seals and sea lions. Orcas live in small groups of five to thirty animals consisting of one or more mature bulls, mature females, and young of various ages. Bulls measure up to 10 meters (34 feet) in length and weigh up to 10 tons. When on the surface their dorsal fins project from the water up to two meters (6.5 feet). They communicate with a repertoire of clicks and whistles that can be heard even by humans on the surface.

Killer whales are one of the most photogenic cetacean species. When traveling, tightly knit groups move along the surface for extended periods, offering varied arrangements of black bodies, spray, and churning water. They generally are not shy of surface craft and will approach small boats out of curiosity. In addition to the

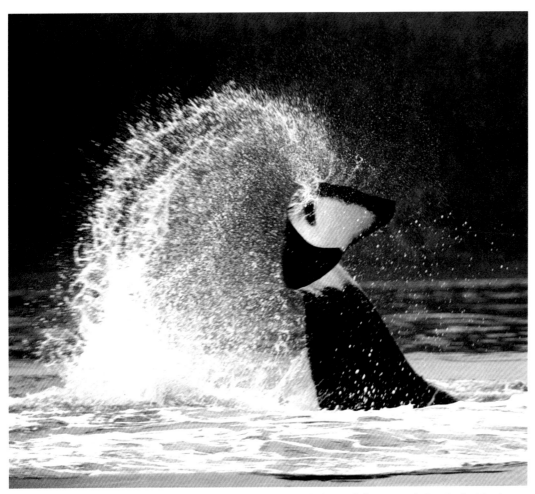

The surface acrobatics of orcas happen unexpectedly, allowing little time to prepare the camera. When tail-lobbing, whales slap the water several times in succession before quitting. If you are quick, there is enough time for one or two shots. If using auto-focus, be sure the focusing sensor is on the whale before activating the focusing mechanism. Otherwise the lens will begin a time-consuming focus search and you will miss the shot. Canon EOS A2, 70-200 mm L Canon lens set at 200 mm, Ektachrome EPP 100, f/2.8 at 1/125 second.

attractive patterns of fins and bodies a group of swimming orcas presents, individual whales perform surface acrobatics consisting of porpoising, full breaches, spy-hopping, and tail-lobbing.

The waters of Johnstone Strait are often calm, especially in the early morning, which creates strong visual contrast with the whales' dark bodies and the ripples and splashes that arise when a pod breaks the surface. The geographic orientation of the strait embraces early morning sunlight even though the strait is surrounded on both sides by mountains.

The best time of year to photograph is August when the orcas gather to feed on schooling salmon. The weather is usually warm enough on shore for T-shirts, although it is much cooler on the water. Overcast skies and rain are possible.

ACCESS AND ACCOMMODATION

From Vancouver the most direct ferry link to this

part of Vancouver Island is from either the Tsawwassen or Horseshoe Bay ferry terminals to Nanaimo. (There is no road access to Johnstone Strait from the mainland.) From Nanaimo it is about a four-hour drive to the picturesque resort village of Telegraph Cove, the best departure point for finding whales. Small boats, or small boats with guides, can be hired from the Telegraph Cove Resort (☎ 800 200 4665). There are larger boats that take out whale-watching groups. Although less expensive, these boats seldom get close enough for dramatic views and the deck is too high above the water to yield intimate portraits.

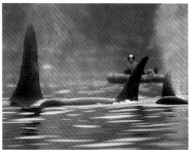

Above: Orcas frequently approach kayaks and other small craft. Right: Keep the camera as low as possible to accentuate the size of the whales' dorsal fins. Focus manually on the emerging dorsal fin (spray will fool auto-focus mechanisms). I also set exposure manually by taking a reading from an area of average brilliance. (The whales' dark bodies may cause over-exposure if auto-exposure is used.) Canon EOS A2, 70-200 mm L Canon lens set at about 135 mm, Ektachrome EPP 100, f/2.8 at 1/125 second.

At the Telegraph Cove Resort, there is a snack shop, a full service campground, and a few rooms and cottages for rent. (Make reservations well in advance.) You can also stay in the town of Port McNeil, only 15 minutes away by car, which has modern, moderately priced motels, restaurants, gas stations, grocery stores, and pharmacies.

SHOOTING STRATEGIES

The best way to photograph the whales is to hire a boat from the Telegraph Cove Resort. It is easy to find your way around and there are normally plenty of pleasure and commercial craft in the strait if you need assistance. You should purchase a chart of the neighboring waters at the resort. The for-hire boats are open and the water is cold, so regardless of the forecast, wear warm, woolen or polypropylene garments—including gloves and hat—and have raingear on board in case a storm develops. Try to be out on the water for sunrise when the sea is most likely to be calm. From the Telegraph Cove dock, it will take less than a minute to reach the open strait where

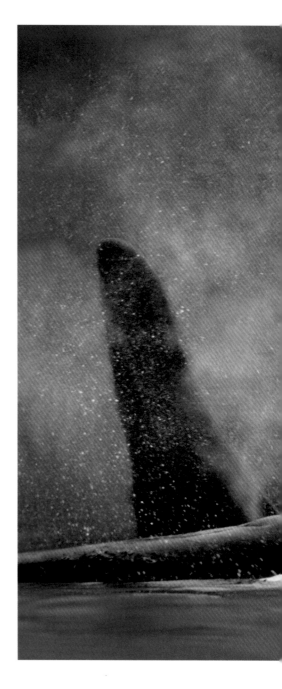

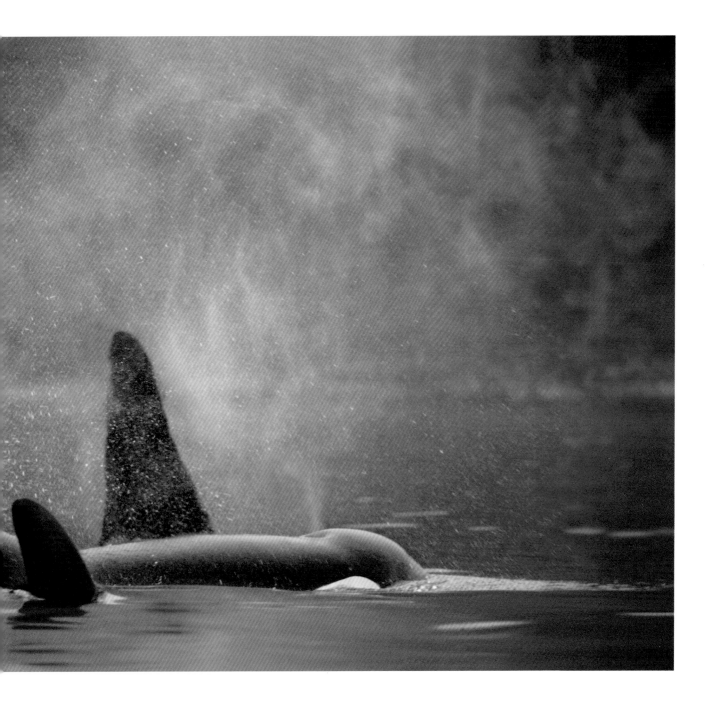

Above: Black oystercatchers are common on rocky or gravel beaches, especially near mussel beds. With patience, they can be stalked for close-up views with lenses of 500 mm or longer. Right: Northern sea lions can be photographed by drifting toward their haul-out spots in a small boat or kayak. Canon EOS A2, 300 mm L Canon lens, Fuji-chrome Velvia, f/4 at 1/250 second.

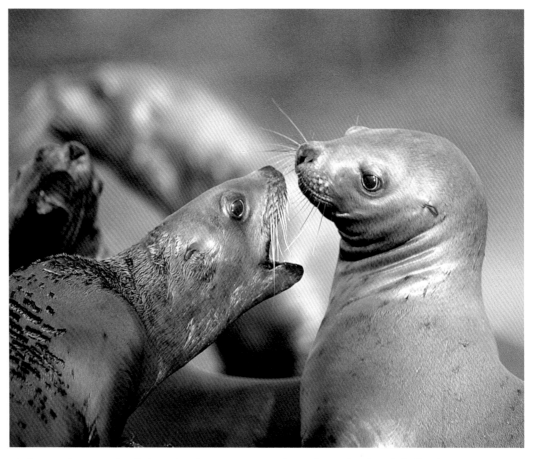

whales may be encountered at any juncture.

If there are whales in the area, you should find them in the stretch of water between Telegraph Cove and Robson Bight, about 45 minutes by rental boat to the southeast. There is little advantage in going further afield. A four-hour excursion will usually result in some exciting photography. If the water is rough, photography will be poor and you may wish to wait for better conditions.

When whales are sighted, try to maneuver into position to intersect their line of travel. Shut off the engine and wait quietly for them to pass. Shoot when the whales draw within range, then wait until they have moved off at least one hundred meters before starting the engine and repeating the process. You won't have any luck pursuing or shadowing the whales because they will become irritated by your presence and disappear.

This work calls for a telephoto zoom in the 100-300 mm range. (I use an 80-200 mm f/2.8 Canon with a 1.4 X teleconverter.) A film of ISO 100 will provide enough speed for blur-free,

handheld exposures provided you are properly focused. Auto-focus is of little help because the movement of the whales and bobbing of the boat often pull the sensor off target and cause the focusing mechanism to search to infinity and back for the subject, by which time the shot is lost. It is easy to focus manually on the emerging tip of the dorsal fin and begin shooting as the whale surfaces. Keep the camera as low as possible to throw the background out of focus and accentuate the height of the dorsal fins.

OTHER ATTRACTIONS

In these waters you are likely to encounter harbor seals, northern sea lions, and river otters. There are boat excursions from Telegraph Cove to salmon streams where black bears are feeding. Pacific Rim National Park, on the outer coast, is the top destination for nature photographers visiting Vancouver Island. Here you will be able to capture pristine wilderness seascapes with big surf and rocky headlands, as well as eagles, shorebirds, seals, and sea lions. Some of the most interesting stands of mature rain forest are along the West Coast Trail (hiking only) south of Bamfield. Tourist bureaus, located at regular intervals along the main highways, provide specific information about the island's natural attractions.

The beautiful old growth forests at Cathedral Grove near Parksville are conveniently located beside the highway leading to Pacific Rim National Park. Numerous trails wind through the immense Douglas-firs, western hemlocks, and western redcedars providing a variety of views. For saturated color, the grove is best shot on a rainy/misty day. Canon EOS A2, 28-105 mm Canon lens set at 105 mm, polarizing filter, Fujichrome Velvia, f/11 at 1/15 second.

21

Elephant Seals

Islas San Benito, Mexico • December to March

A few elephant seals are likely to be encountered on the beach at Isla San Benito where you first land (right). The rookeries are on the opposite side of the island, about a ten minute walk from this beautiful harbor where the fishing camp is located.

ISLA SAN BENITO IS the largest of a group of three islets lying 130 kilometers (80 miles) off the Pacific coast of Baja, Mexico. Far removed from the tourist trails that lace the Baja, it can be an adventure just to reach the island's rocky, wave-battered shores. Should you make the journey, you will be well re-warded by the abun-dance of marine life and the spectacular wilder-ness setting.

The main attraction on Isla San Benito is *los elefantes*—the northern elephant seals that con-vene here by the thousands from the far reaches of the Pacific to bear young and to breed. The largest bulls, weighing up to three tons, arrive in Novem-ber and engage in brief but violent battles to es-tablish a claim to the island's real-estate. A few

weeks later the females arrive. Considerably smaller (weighing under one ton), females gather into harems, bear a single young a few days later, and begin mating soon after in preparation for the next year's calving season. Day and night for several months, these crowded, sun-bathed rookeries are overtaken by an orgy of sex, violence, and little else.

Isla San Benito's other attractions in-clude ground-nesting ospreys, California sea lions, and landscapes reminiscent of the Or-egon coast.

ACCESS AND ACCOMMODATION

During the abalone season (usually November through March) Isla San Benito is inhabited by

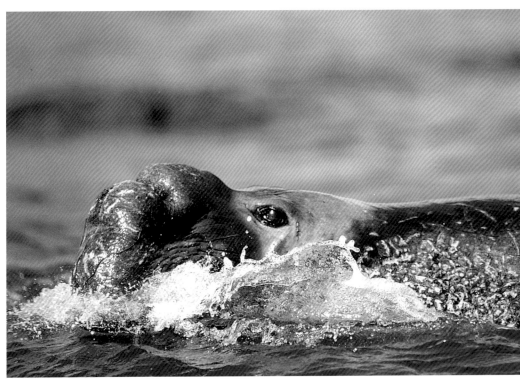

You can walk through the rookeries on Isla San Benito without restriction. Nevertheless, you should move slowly and avoid approaching the animals so close that they become alarmed. I wore chest waders and sat in the water behind my tripod to record this bull swimming into the beach. Canon EOS A2, 400 mm L Canon lens, Ektachrome EPP 100, f/2.8 at 1/1500 second.

several dozen Mexican fishermen who occupy a permanent camp on the eastern side of the island. Each day except Sunday, a supply ship arrives from nearby Isla Cedros to pick up abalones and drop off fresh containers of ice for packing the next catch. This small supply ship is the safest and most reliable way to reach Isla San Benito. From Isla Cedros the journey takes three to four hours. There is no charge for passage and no practical limit on the amount of gear you can bring!

There are daily, inexpensive flights to Isla Cedros from the towns of Ensenada and Guerrero Negro (on the Baja mainland) on *Aerolineas California Pacifico* (☎ 52 66 71000). The flights arrive too late for you to board the supply ship to Isla San Benito, so you must stay overnight on Isla Cedros. The taxi driver at the airstrip will take you to the only (very poor) hotel on Isla Cedros, where a room costs about the same as a single roll of film. While waiting for the boat to Isla San Benito, which leaves about 8:30 a.m., you will need to stop at the office of the *Sociedad de Pescadores Abalones de Mexico*, located on Cedros' main (unpaved) thoroughfare, and get formal permission to board the supply ship.

On Isla San Benito there are no facilities of any kind for visitors. You must take everything you need for your stay, including food, shelter, and drinking water. There is plenty of firewood along the beach. The fishermen are well provisioned, enjoy the diversion of foreign visitors, and seem happy to help however they can.

The elephant seals are found on the west side of the island, which is a good and private area to situate your campsite. The weather tends to be pleasantly cool and breezy, so set up your tent in a sheltered area behind boulders. I have camped just above the rookeries where it is easy to keep an eye on the action. I would not venture a trip if a storm is forecast. The seals are generally unafraid of humans, provided you keep a two to three-meter (6.5 to 10-foot) distance. Protect your supplies carefully when you are away from camp. I lost most of my food, including a roast chicken, to a clever trio of feral burros! The boat back to Isla Cedros usually leaves around noon, and you should be ready to embark, with all your equipment on the beach, about an hour before.

Water is one of the most attractive pictorial elements in marine wildlife photographs and I try to incorporate it into compositions whenever I can. Its movement cannot be appreciated by the naked eye in the same way that it can be recorded on film. Here, two 'weiner' elephant seals are swamped by an incoming wave while keeping a wary eye on the photographer. Canon EOS A2, 400 mm L Canon lens, Fujichrome Velvia, f/4 at 1/500 second.

You are not likely to find anyone on Isla Cedros or Isla San Benito that speaks English, so don't forget your Spanish phrase book. Despite the apparently simple travel arrangements described above, be forewarned that you might encounter delays, even of several days. In addition, the abalone fishermen may be unexpectedly shifted to another area, which means the regular supply ship to Isla San Benito will not be running. The best way to obtain this information is to talk to the people at *Aerolineas California Pacifico*, which can be difficult if you do not speak Spanish.

SHOOTING STRATEGIES

Bulls fighting, social preliminaries to mating, and seals of all ages swimming and loafing in the shallows are some of the activities well worth photographing. Although you can get as close to the animals as you wish (there are no restrictions), a telephoto zoom lens in the 200-400 mm range will be the most useful focal length. The action is fairly continuous both day and night but it stops and starts abruptly at different locales, allowing little time to reposition a tripod-mounted camera. It is usually best to take up a vantage point in good light and wait patiently for shooting opportunities. The telephoto zoom will provide adequate reach and a variety of framing choices. The island's ambient light is high in contrast with little reflection from the beach, so shooting late and early in the day will produce the most pleasing results.

OTHER ATTRACTIONS

Sandy coves are tucked among the rocky headlands all along the windward (western) shore of the island, each with its own compliment of elephant seals. On the rugged, cactus-strewn plains above the beaches are dozens of osprey nests, usually separated by about one hundred meters (100 yards) or more. The nests are built on low piles of rock and the terrain is such that you can often

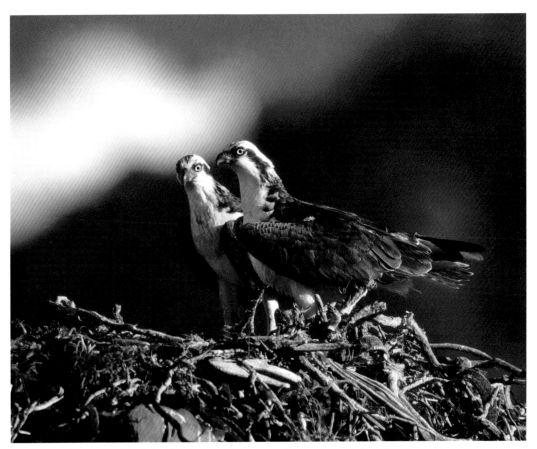

Left: One of the many osprey nests built on rock piles along Isla San Benito's windward coast (below), it was located near a hillside overgrown with scrub in which I hid to take the photo. I didn't fool the birds, however, which tolerated my presence while they brought new sticks to the nest. Canon EOS A2, 400 mm L Canon lens, 2X tele–converter, Ektachrome EPP 100, maximum aperture at 1/500 second.

walk up to the nest and look in. To photograph the ospreys, it is necessary to set up a blind which you should bring with you. In mid-March (the latest opportunity to photograph elephant seals), most of the ospreys are still incubating, but are nevertheless quite tolerant of photography from a blind.

On the two adjacent islets (Isla Media and Isla Norte), there are more elephant seals and hundreds of California sea lions hauled out on rock and sand beaches washed by clear, turquoise waters. You must find a fisherman to take you there in one of the small boats used for abalone fishing.

You are not likely to be charged but a generous tip is well advised and will be agreeably received. Be prepared for a hair-raising ride in high seas.

The windward coast of the island is spectacular, with high cliffs and towering seastacks meeting the swells and heavy waves of the open Pacific. A rough foot path runs along the shore for several miles, linking the fish camp to the lighthouse. From this path there are many excellent places to set up a tripod.

Humpback Whales

Frederick Sound, Alaska • August / September

Frederick Sound offers beautiful northern scenery in addition to marine wildlife. This islet, covered with sandpipers at high tide, is located adjacent to the village of Kake. The rocks also are used as a roost by bald eagles. This photograph was taken a few minutes after sundown from a tripod set up on the beach. Canon EOS A2, 400 mm L Canon lens, 1.4X teleconverter, Fujichrome Velvia, f/8 at 1/15 second.

AN EXPEDITION TO coastal Alaska brings you into contact not only with numerous humpback whales but a number of other large, easily photographed mammals. Among them are black and grizzly bears, sea otters, killer whales, harbor seals, and northern sea lions. Humpback whales migrate here for the summer season to feed on krill, herring, and other fish.

Humpback whales are one of the most spectacular wildlife subjects. Adults average nearly 13 meters (42 feet) in length and weigh as much as 30 tons. When the mood suits them, they are the most acrobatic of cetaceans, breaching repeatedly and rolling about the surface, slapping the water with great tails and five-meter (16.5-foot) flippers. Their flippers and bodies are cov-

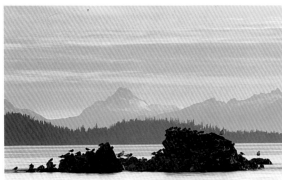

ered with barnacles and they eject powerful bursts of spray when surfacing. They are curious about humans, especially children, and sometimes approach boats to within petting distance. I have been forced to duck while shooting when one humpback swung its tail over the boat.

Whales are most abundant in Frederick Sound during August and the first half of September. The small logging and fishing village of Kake, on Kapreanof Island, makes an excellent staging area for photography.

Besides being within easy speedboat range of whales, sea lions, and sea otters, the community is situated on Gunnuk Creek, which is choked every

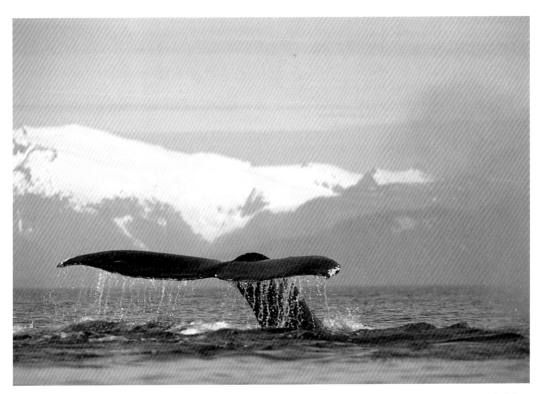

When photographing whales, it's best to hand-hold the camera and keep it as low as possible. Manual focusing is the most reliable way to get sharp images due to the difficulty of keeping an auto-focusing sensor on the target when working from a rocking boat. Use a shutter speed about 50% higher than the reciprocal of the lens focal length together with as small an aperture as lighting conditions permit (for maximum depth-of-field). Take special care to keep the horizon level, something that is easy to forget in the excitement of shooting. As these photos demonstrate, a variety of lighting angles is effective when working with whales.

summer with spawning salmon of several species and dozens of human-habituated black bears gorging themselves on fish.

The weather in Frederick Sound during the summer varies from sunny and warm to overcast, cool, and rainy. Temperatures on the water are considerably cooler. Rain gear and woolen-weight apparel are necessary.

ACCESS AND ACCOMMODATION

Kake can be reached by charter plane (LAB Flying Services, ☎ 800 426 0543) from Juneau. There are two satisfactory hotels in the village. The Waterfront Lodge (☎ 907 785 3472) is centrally located and situated right on the beach. Scores of bald eagles gather at low tide only a few meters from the hotel's porch. Kake has one restaurant, a sandwich shop, and two grocery stores with adequate selections of food and other supplies.

To photograph the whales and other marine life in this part of Frederick Sound, you should hire a guide, not only to find wildlife but to safely navigate the icy, frequently rough waters and numerous rocky shoals. You will encounter few other boats in the area. The Kake Tribal Corporation (☎ 907 785 3221) provides information on tourist services. Also, contact Cornell Bean (☎ 907 785 3242), a lifelong resident of Kake and an excellent guide with fast, safe boats. Cornell will make your experience enjoyable; if he is busy, he will provide alternate recommendations

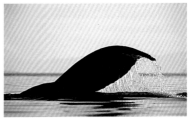

27

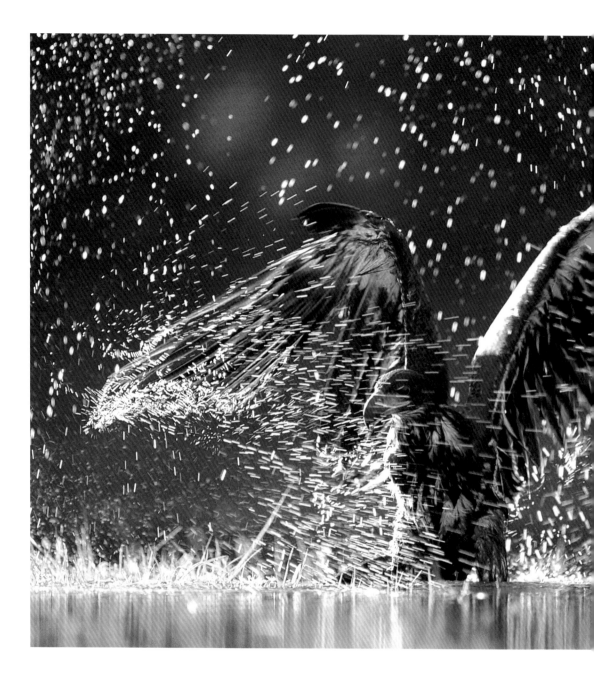

for a boat. You will have to arrange privately for a car.

SHOOTING STRATEGIES

You may encounter whales anywhere in Fred–erick Sound, but the most likely areas will be near rocky islets where schools of herring are spawning. These schools attract hungry hump-backs which sometimes feed co-operatively by blowing a circular net of bubbles

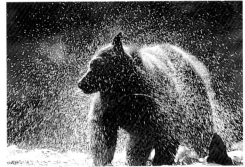

around the herring. When the net is in place the whales swim through its center to the surface with jaws agape, lunging out amid a cascade of water and terrified fish. (Witnessing this behavior will likely be the highlight of your photographic experience here.) Position the boat near the ring of bubbles that appears on the surface, paying attention to the lighting and background. The action breaks with little warning and lasts only a few seconds at a time. Be ready to shoot!

You will encounter other humpback surface activity commonly. Normally the humpback spends a few minutes on the surface, taking three or four breaths before submerging for five or six minutes to feed, travel, or socialize. It is best to bring the boat within camera range and cut the engine. The whales often approach for a closer look. You should also use the 'interception strategy' described previously for photographing orca pods. It is the whales that decide whether you can remain within camera range. Unless you respect their desire for peace and quiet, they will disappear.

When shooting, use a handheld, motor-driven

Back-lighting dramatizes splashing and spraying water. It can be used most effectively when the subject is set against a dark background. With the shaking black bear (above), I positioned the camera to capture the bear against the stream bank which was shaded by trees. The immature bald eagle (left), like the black bear, was photographed on Gunnuk Creek while feeding on salmon. For both images, I set exposure by taking a manual, in-camera, spot-meter reading from an average front-lit subject.

camera equipped with a medium, telephoto zoom lens and loaded with ISO 100 film; set the controls for manual focus and manual exposure. Kneel in the bottom of the boat for extra stability and to keep the camera low to the water. You have several seconds to focus on the whale's tail as it submerges for a deep dive. Back-lighting adds drama to this photographic opportunity, accentuating the cascade of water from the edges of the flukes. If a whale is breaching, its first leap comes without warning and is nearly impossible to catch on film, but it may signal the beginning of a series of breaches (sometimes a dozen or more) in the same location, which makes framing and focusing much easier. The best time for shooting is early and late in the day when the waters of Frederick Sound are often smooth and reflective of the sky's rich color.

OTHER ATTRACTIONS

Gunnuk Creek is a five minute walk south along the main road from the center of the village. Here you will find, at all times of the day during August and early September, up to a dozen black bears fishing along a hundred-meter stretch of the creek adjacent to the road. More bears are hidden in the underbrush, including mothers and cubs! The bears are not afraid of humans and some of them will allow you to approach as close as you dare. Be aware that there is no possibility of a human out-running a black bear. Be especially cautious around mothers with cubs. Use a 500 mm lens or longer and allow the bears a comfortable space for relaxed fishing. If you are quiet, stay low, and don't move around, you will have many chances for great photos. The only drawback is the poor quality of light—the creek is shaded on both sides by tall conifers. Overcast days are ideal, providing the soft light needed for a subject as high in contrast as a fishing blackbear.

At low tide from the porch of the Waterfront Lodge, you can see as many as 50 bald eagles perched on driftwood and gravel bars. Like the black bears, they are attracted to the dead salmon scattered along the shore of the bay. Unlike the bears, they are wary of humans and portrait photographs are only possible from a blind. Should you not have one with you, you can put one together from the profusion of scrap lumber laying around Kake and along the beach.

To find sea otters in kelp beds and sea lions

When shooting the black bears at Gunnuk Creek, I tried to keep the camera as low as possible. This placed the bears against an out-of-focus distant background, which accentuated by contrast the sharpness of the main subject. Canon EOS A2, 400 mm L Canon lens, 1.4X teleconverter, Fujichrome Velvia, maximum aperture at 1/350 second.

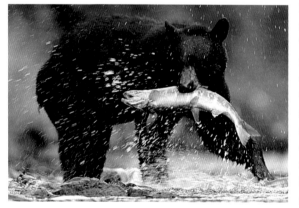

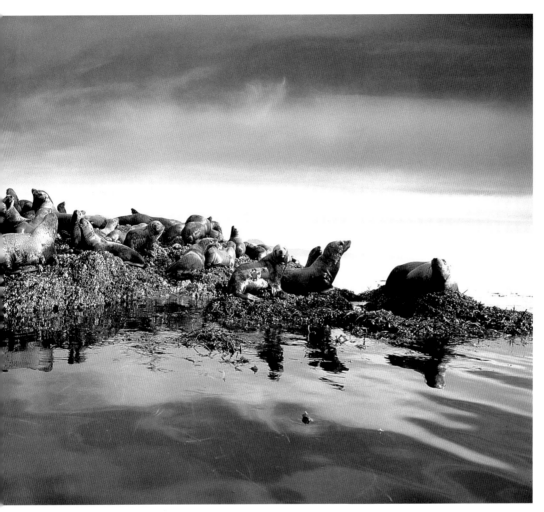

These northern sea lions were resting on a small island in Frederick Sound. At first, they barked in alarm at our arrival and a few animals dove into the water. But they soon calmed down and we were able to drift, with the motor off, to within a few feet of the islet without frightening them. Canon EOS A2, 20 mm Canon lens, Cokin graduated neutral density filter, Fujichrome Velvia, f/4 at 1/60 second.

massed by the hundreds on rocky islets, you will have to use a boat and a guide. The trip to photograph otters takes a full day, but several sea lion haul-out areas are within an hour or less of Kake. You can approach either species as closely as you wish, provided you drift toward them slowly and quietly with the motor off.

There are many seashore and forest scenes that can be reached via the network of logging roads surrounding Kake. It is possible to rent or borrow a car from one of the local people if you wish to explore Kapreanof Island by land.

Northern Fur Seals

St. Paul Island, Alaska • Summer

The weather on St. Paul Island is cold and wet with rare sunny breaks. Contrasty films and fast lenses will make the best of the soft, low-level light. Wildflowers, especially lupines, (right) are profuse, but steps must be taken to shield subjects from the wind which seldom abates over this remote outpost. Bird rookeries are located along these cliffs. The fur seal colonies are concentrated inland.

ST. PAUL ISLAND IS familiar to birdwatchers who venture to this lonely, fog-shrouded outpost in the Bering Sea to observe colonies of seabirds nesting in the nooks, ledges, and grass turf of the island's precipitous ocean-side cliffs. Eclipsing this avian spectacle, however, is the largest single herd of mammals anywhere in the world. During the arctic summer, there are more than a dozen active fur seal rookeries and haul-out areas totaling well over a million animals, most of which are engaged in breeding and/or bearing young. Other attractions for the nature photographer are fog-shrouded seascapes, exceedingly tame blue-phase arctic foxes, a nervous herd of caribou, and colorful displays of arctic wildflowers.

Adult fur seals are closely related to sea lions. Females weigh up to 60 kilograms (130 pounds), and males up to 272 kilograms (600 pounds). They are playful creatures with a strict social order. Bulls arrive on St. Paul in early June and fight savagely to establish territory. The females arrive a couple of weeks later and quickly divide into harems, give birth (most pups are born in mid-July), and about a week later begin mating with the dominate bull—or beach master. By mid-September most of the seals have left for southern latitudes.

It is always cold and wet on the island, so bring warm clothes, gloves, hat, rubber boots, and raingear.

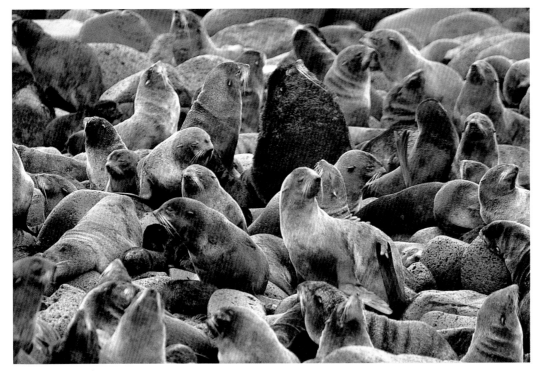

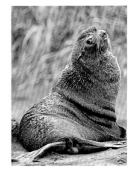

Left: Fur seal rookeries are generally organized into harems, at the center of which is a large bull (the beach master). Due to low light levels and constant movement by the seals, fast film (ISO 200) is helpful to attain a sharp image with full depth-of-field of a mass of animals. Below: You will encounter many young bulls wandering about the periphery of the rookeries. These individuals are very aggressive and deserve a wide berth.

ACCESS AND ACCOMMODATION

St. Paul Island, the largest in the Pribilof Archipelago (8.7 by 5 kilometers [14 by 8 miles]), is accessible on Reeve Aleutian Airways (☎ 800 544 2248) from Anchorage. The flight passes over spectacular volcanic landscapes and seas. The village of St. Paul is a small Aleut community of colorfully painted houses, a Russian Orthodox church, and a single comfortable hotel—The King Eider (☎ 907 546 2312) which has shared baths and a good, no-frills restaurant. The village provides shuttle buses to take its few tourists to the various natural history attractions, including the bird cliffs and seal rookeries. For independent travel, you should have no trouble arranging private rental of an all-terrain vehicle (the island's primary method of locomotion) from one of the villagers. This will make for much more productive shooting, as walking distances to the rookeries are strenuous for heavily equipped photographers.

SHOOTING STRATEGIES

The fur seal is readily disturbed by humans, thus many of the haul-outs and rookeries are protected from close approach. This does not hinder shooting because blinds have been set up that allow for intimate photography, and many seals, especially the bulls, wander all over with little regard for the boundaries. Bulls are fast and aggressive, armed with stout teeth, and require a wide berth from photographers.

Lenses ranging from fish-eye to 500 mm will prove useful, given that you can shoot individuals and entire rookeries at various times from

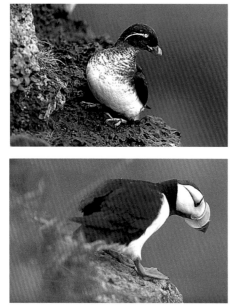

You need a long lens and, due to the wind, a sturdy tripod to photograph St. Paul's seabirds. Most species can be approached closely without a blind, but all are nervous and require the photographer to remain as still as possible. The tufted puffin (right) was photographed as it flew into a strong headwind, which slowed its progress and made manual focusing easier. Canon T90, 500 mm L Canon lens, Fujichrome 50, f/4.5 at 1/350 second.

whatever distance you chose. The skies are invariably overcast, so a high contrast film, such as Fujichrome Velvia, will yield good contrast and saturated colors. The low light levels call for a tripod in most situations. This is the high arctic, where short summers provoke non-stop animal activity throughout the day. As a result, there is little advantage to getting an early start, as the light will be weak and undramatic due to overcast skies.

OTHER ATTRACTIONS

The seabird rookeries are scattered along the cliffs that surround St. Paul Island. At diverse vantage points, thousands of birds are visible, many practically within touching distance. These include least, crested, and parakeet auklets; common and thick-billed murres; northern fulmars; horned and tufted puffins; and others. The red-faced cormorants and red-legged kittiwakes found here are avian specialties generally restricted to the Bering Sea. The most popular photographic subjects are the puffins. Not found in the abundant numbers of some other species,

they must be carefully approached with the longest lens in your optical arsenal. Frame-filling portraits are hard to obtain with lenses less than 700 mm.

There are numerous blue fox dens scattered about the island, some within a stone's throw of the King Eider Hotel. On several occasions, I nearly stepped on foxes sleeping on the tundra. They feed on seabirds, seabird eggs, and carrion from along the beach. Each pair of foxes patrols a small bit of territory in the vicinity of its den, which is usually located on the beach among the jumble of dark, sheltering boulders. You can approach the den with slow, cautious moves, allowing the foxes to become accustomed to your presence. Within a few hours you can carry on shooting with little notice from your subjects. Some of the dens have pups.

The driver of the shuttle bus, who makes regular pick-ups at the King Eider Hotel, will be happy to drop you off in the general vicinity of the caribou herd that ranges over the island's interior tundra. But there is no guarantee of finding the skittish herd or getting picked up again by the

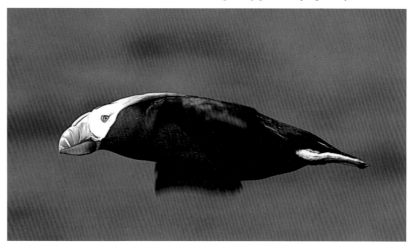

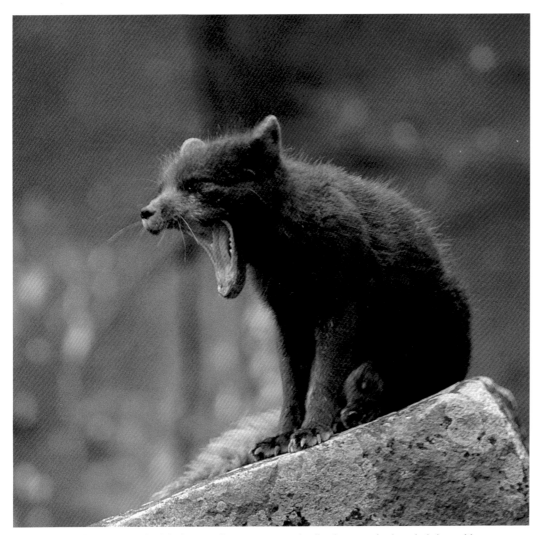

Blue-phase arctic foxes are common on St. Paul Island. They are unafraid of humans and can be easily photographed once you become familiar with their habits. I kept an eye on this individual until I observed him entering his den. I set up a tripod a short distance away and began taking pictures when he reappeared after his nap. Due to the slow shutter speed, I tried to time the exposure to catch the fox at the 'top' of his yawn. Canon T90, 500 mm L Canon lens, Fujichrome 50, f/4.5 at 1/60 second.

shuttle—even if a precise schedule is agreed upon with the driver in advance.

The tundra is covered with wildflowers of various species. They are typically soaked by incessant mists and light rain, resulting in saturated color and glistening droplets. The soft light couldn't be better for macro photography. The only disadvantage is the wind that seldom stops, making it necessary to shoot in sheltered locations or behind a windbreak of your own making.

Bottle-nosed Dolphins

Roatan, Honduras • January to September

Roatan offers great opportunities for tropical seascapes even at mid-day. Much of the island, especially at the east end, is undeveloped. A healthy coral reef encircles the island and marine life is plentiful, offering a many subjects for underwater photography.

ROATAN IS A RUGGED, banana-shaped island about 35 miles off the coast of Honduras. Practically the entire 25 kilometer (40 mile) long island is fringed by a healthy coral reef and clear turquoise waters rich in underwater life. The island is picturesque, boasting numerous white-sand beaches, quiet palm-fringed coves, and stretches of mature tropical and upland pine forest. There is a low-key tourist infrastructure, including many diving resorts. The Institute of Marine Sciences (☎ 504 45 1327), located at Anthony's Key Resort, offers diving in open water with bottle-nosed dolphins. These animals are participants in the on-going research programs conducted at the institute. Although they are kept in pens at the resort, the dolphins may swim and forage freely in the open ocean (accompanied by their trainers in boats), returning to the resort when requested. The best time to photograph dolphins and other marine life is during the dry season (February through September) when the offshore waters are clearest.

The bottle-nosed dolphin is the best known of the cetaceans, having been studied extensively in aquaria and exhibited in acrobatic shows to countless spectators. It is a powerful animal, reaching nearly 4 meters (12 feet) in length and weighing up to 800 kilograms (1700 pounds). Dolphins feed on fish primarily in shallow water.

36

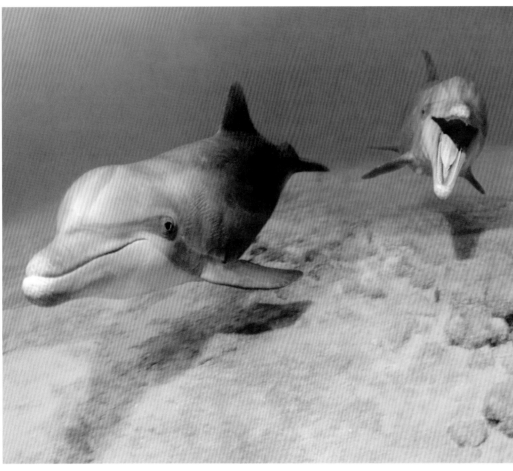

I tried to stay as low as possible in order to record the dolphins against the surface or against an out-of-focus background. I set the camera on continuous (servo) auto-focus and center-weighted auto-exposure. Far from an accomplished underwater photographer, I nevertheless attained some nice images after three dives. You will have numerous opportunities to photograph the dolphins swimming toward you—and they swim slow enough for auto-focusing to keep up! Canon EOS A2, Delphinus housing, 15 mm Canon fish-eye lens, Sea and Sea YS 120 strobe with diffuser (set for full fill-in flash), Ekta–chrome EPP 100, f/4 aperture priority auto-exposure.

They are social, traveling in groups of up to 25 animals and communicating by various clacks, clicks, whistles, and yelps. They are highly intelligent, with a brain-to-body ratio greater than any other animal except the human.

Due to the health of its extensive and varied coral reef system, much of it protected by law, Roatan is a sanctuary for marine wildlife as rich as any in the western Caribbean. In addition to underwater subjects, the tropical land and sea scapes offer idyllic, unspoiled scenes, particularly at the eastern end of the island. The jungles and forests have been cleared in many areas for cattle ranching, but extensive tracts are preserved in the Port Royal Watershed.

ACCESS AND ACCOMMODATION

Roatan can be reached by direct flights on Taca Airlines (☎ 800 535 8780) from the United States. A number of other airlines (Continental, American, Lacsa) provide service to Roatan interrupted with stops or transfers on the Honduran

mainland. There is a variety of lodgings and eateries on the island. A convenient kiosk at the airport provides information and reservations for most of the island's accommodations. The attendants will also arrange for car rental, which is inexpensive and necessary for getting to the various photographic attractions. For a moderately priced, quiet, well-situated place to stay, I recommend Seagrape Plantation Resort. If price is no concern, stay at Anthony's Key Resort where you can rent underwater equipment.

The weather in Roatan is tropical with lots of sunshine and occasional showers. Avoid the rainy season which usually lasts from September into December.

SHOOTING STRATEGIES

The dolphin dives are limited to six participants and take place in about 17 meters (55 feet) of water. The bottom is white sand surrounded by large, soft corals. Schedule your dive for midday, when the ambient light is strongest. The dolphins can be photographed at any range, including silhouetted shots at the surface. Your widest lens, up to and including fish-eye, will produce the best results. If using ISO 100 film, you will find fill-in flash useful, not only to boost shadow illumination but to warm up the light, which is very blue at this depth.

For natural backgrounds you can swim near the corals even though the rest of the diving group is out in the sandy area. Out of curiosity, the dolphins will pay you regular close-up visits. For the most shooting opportunities, stay close to the trainer, whom the dolphins swim past frequently. I stay as low as possible (about a third of a meter [one foot] off the bottom). This forces the dolphins, who also like to cruise at this depth, to swim above you where they can be photographed against an uncluttered background or the surface. Be careful not to disturb the sand, which clouds the water. The dive lasts about 45 minutes. You cannot return to the boat to reload the camera, so conserve your roll of film. Save a few frames for the ascent so you can shoot the dolphins in natural light at the surface. If you wish to do this, leave a few minutes before the rest of the group, as the dolphins head back very soon after the dive is over.

OTHER ATTRACTIONS

There are endless other beautiful underwater subjects—including hard and soft corals, sponges, turtles, crabs, morays, groupers and other fish—and you may be tempted to photograph nothing else. On the island the forests offer most of the typical subjects of the western Caribbean region, such as iguanas, boas, herons, ospreys, hummingbirds, agoutis, and a host of spiders and insects. Away from the tourist developments, this is a classic, tropical island experience with numerous, uninhabited white-sand beaches, and secluded coves.

Right: I used the 'catch-and-release' method to photograph this green iguana. The local people catch iguanas for the dinner table, so I hired a couple of boys to bring one to me alive. I cooled it down in the refrigerator before setting it in this palm frond where it posed for a few minutes before heading back into the bush at lightning speed. Canon EOS A2, 70-200 mm L Canon lens set at 200 mm, 25 mm extension tube for close focusing, Fujichrome Velvia, f4 at 1/180 second

Landscapes

Ocean Waves

Island of Oahu, Hawaii • November to March

The big-wave beaches on Oahu are only a short walk from the island's main highway. The largest surf is found along the sandy beaches of the north shore during the winter. Many of the rocky headlands around the island also have large waves which generate plenty of photogenic spray and foam.

DURING THE WINTER, the beaches on the north shore of the Island of Oahu are pounded by the largest rideable surf in the world. The ocean is sculpted by land and wind into well-defined waves up to 9 meters (30 feet) high that break close to shore. On high-surf days, only the elite of the surfing fraternity dare to practice their art. For most of the year, northeast trade winds prevail, bringing swells across 3,200 kilometers (2,000 miles) of the open Pacific. The islands of Hawaii, lacking a continental shelf to deaden the impact, receive the full force of the ocean's momentum. Surf levels rise and fall independently of the local weather, often as the

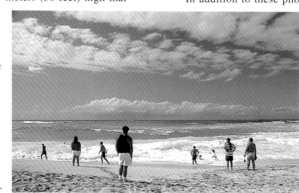

result of storms as far away as the Aleutian Islands. Occasionally the winds shift and come from the south, blowing against incoming swells and stacking the waves to fearsome proportions.

In addition to these photogenic, wave-battered beaches, some others are in a natural state, fringed with palm trees and spread with light-colored sand fronting deep blue and turquoise seas. Sunsets and sunrises are frequently spectacular, with enough clouds on the horizon to capture and reflect the atmosphere's many colors.

The weather during the winter is generally sunny, warm, and humid with steady breezes—

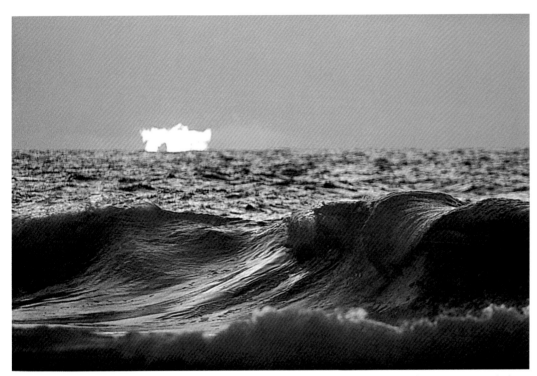

The manner in which the texture and flow of water is recorded by the camera is often surprising. The most important factors to consider are lighting angle (a low sun produces the most dramatic results) and shutter speed (any speed from action-stopping to motion-blurring may produce pleasing results). Here, back-light from a setting sun and an intermediate shutter speed were used. Canon T90, 500 mm L Canon lens, Fujichrome Velvia, f/4.5 at 1/125 second.

perfect for swimming, snorkeling, and other beach activities.

ACCESS AND ACCOMMODATION

Access is through the main airport at Honolulu, where there are numerous car rental agencies (two-wheel drive is sufficient). Honolulu is a large city thriving on tourism, with hundreds of places to sleep and eat, from economical to luxurious. You will need a map of the city and the Island of Oahu to find your way around.

On the North Shore, the surfing beaches are strung out along Highway 83 between Kawela and Haleiwa. There are few places to stay and most of them are geared to the down-market, itinerant surfing crowd that convenes here from all over the world. The most popular of these accommodations is The Plantation Village (☎ 808 677 0110) across from Three Tables Beach near Shark's Cove, which offers a variety of rooms and cottages at reasonable rates. Reservations are necessary during surfing season. Luxury accommodations are available at the Turtle Bay Hilton Golf and Tennis Resort (☎ 800 445 8667).

SHOOTING STRATEGIES

There are beaches and coves all over Oahu, some very near Honolulu, which offer opportunities for recording beautiful wave patterns and seascapes. These can be easily reached both to the north and south of Honolulu by driving the main island highways that follow the shoreline. There

are lots of pull-outs and small parks where you can stop and spend time shooting. I look for stretches of beach free of development, with some interesting natural elements in the foreground, such as rocks or clean white sand. The main surf beaches are Sunset Beach, the Banzai Pipeline, and Waimea Bay on the North Shore. The waves here are huge, often double or triple your height. In some places they break right at your feet, landing thunderously like a momentary Niagara.

Despite the size and closeness of the waves, long lenses (up to 500 mm) are helpful in recording close-up details while keeping your camera

out of the salt spray and splashes. When shooting, focus carefully on the crest of the wave and trip the shutter as it reaches maximum visual impact. This is not easy because the wave is moving and changing form simultaneously. With each shot, concentrate on tight framing, focusing, and careful timing, and accept the fact that a good percentage of frames will be off-target. Plan on shooting a roll

Wave photography can be carried out with any focal length lens. Above: I used a 500 mm lens to target details of a breaking wave. I usually attempted to capture the crest as it moved toward me. Right: A 20 mm lens exaggerates perspective, stretching out the breaking wave. The camera was positioned on the beach a few feet from the incoming water. A graduated neutral density filter was used to darken the sky.

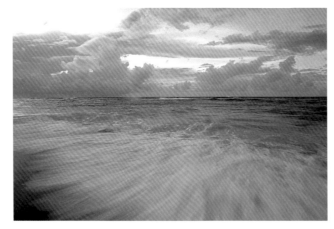

of film or more for each wave set-up you attempt.

Look for docks or rock jetties that extend out into the surf. You can walk out onto these structures and record the waves breaking in profile. Such locations are amenable to blurred motion shots, allowing you to pan along with the moving wave at 1/15 or 1/30 second, capturing it in relatively sharp detail but streaking the background and foreground elements.

Regardless of the shutter speed, wave shots are always a surprise because you cannot see the scene, due to mirror black-out, at the time of exposure. Normally you will achieve good results if you concentrate on well-defined wave patterns in high contrast light (mid-day with sun) and low light (sunrise and sunset). On cloudy days I refrain from shooting waves and photograph the native flora. Saturated, high-contrast films, such as Fujichrome Velvia or Kodachrome 25, produce the most dramatic results.

The best time to shoot beach scenics is often at sunrise or sunset, using a wide-angle lens placed near the area where the water and the land meet. Long exposure times (up to a minute) render the foam of repeatedly breaking and swirling water as

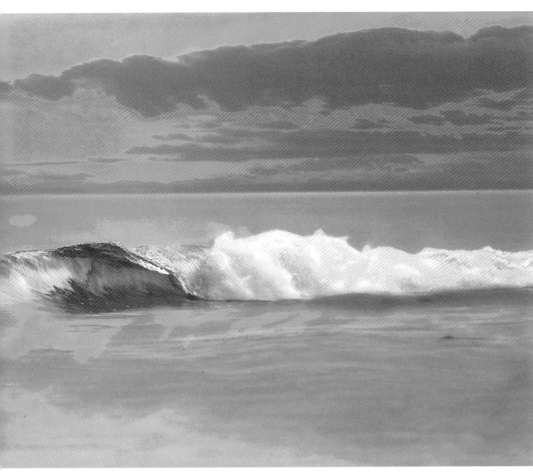

Left: This photo was created from the two images above on a Macintosh computer using a Polaroid Sprintscan 35 Plus desktop scanner and Adobe Photoshop software. The wave component was recorded with a 500 mm lens; the sky with a 200 mm lens and a polarizing filter. Fujichrome Velvia was used for both photographs.

creamy blurs which are especially attractive when juxtaposed against well-defined, stationary elements like rocks or sand.

OTHER ATTRACTIONS

There are several alternate photographic attractions in the North Beach area. Waimea Falls Park is a botanical garden with forest trails and many cultural exhibits. It preserves native flora, including many endangered species. The falls drop 16 meters (55 feet) into a still pool. At low tide at Pupukea Beach County Park, the first park north of Waimea Bay, a long retaining wall forms a large tidepool. Wear sandals or shoes in case you step on an urchin, and check out the pools with a mask. You may encounter large sea bass. In still conditions you can photograph life in the pools by using a polarizing filter to minimize reflections from the surface of the water.

Misty Forests

Great Smoky Mountains
Tennessee & North Carolina • Spring / Autumn

Great Smoky Mountains National Park has many viewpoints from which great expanses of pristine forest can be photographed. The view from Clingman's Dome (right) offers a layered panorama best photographed at dawn or dusk when the mists rise from the moist forest landscape. Canon T90, 300 mm L Canon lens, Cokin graduated neutral density filter, Fujichrome Velvia, f/8 at 1/4 second.

GREAT SMOKY MOUNTAINS National Park's half million acres are covered with thick forests of great species diversity. On high ridges, some more than 1,800 meters (6,000 feet), are northern tree species typical of the forests of Quebec and New England, including balsam fir, eastern hemlock, red spruce, and aspen. Mid-elevations support oak/hickory and beech/maple associations typical of the Great Lakes region. The valley bottoms are spread with old-growth forests of tulip-tree, hickory, black tupelo, sycamore, silverbell, sugar maple (containing many world-record sized hardwoods), and numerous southern species such as pawpaw, magnolia, and Kentucky cofteetree. These luxuriant forests keep the landscape cool,

even in summer. The moisture and turpenes given off by the trees are partly responsible for the smoke, or blue haze, for which the region is named.

In springtime, the forest understory has much to offer photographers. In addition to the blooms of silverbell, dogwood, tulip-tree, and magnolia, there are evergreen shrubs, mostly laurel and rhododendron, whose pink and white flowers open in the late spring and early summer. In early May, the forest floor is sprinkled with wildflowers of many varieties: trillium, trout lily, Dutchman's breeches, phacelia, and bluets to name only a few. In autumn (especially the last two weeks of October) the forests are transformed by the turning foliage, which sets

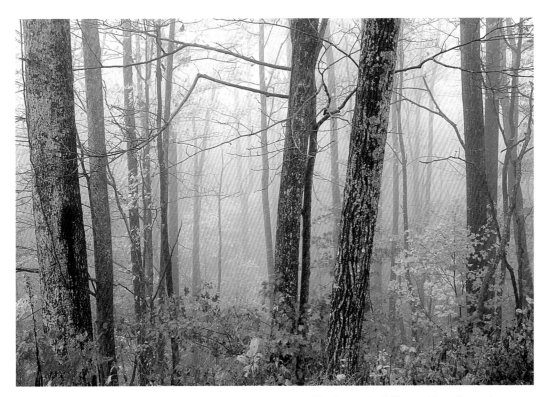

Foggy days are ideal for shooting forest scenes. Fog enhances the impression of three-dimensional space by reducing the clarity of the scene's distant elements, making them appear further away than they actually are. Canon T90, 80-200 L Canon lens set at about 150 mm, polarizing filter, Fujichrome Velvia, f/11 at 1/4 second.

ablaze the rolling terrain from horizon to horizon. Hundreds of thousands of tourists (known to the locals as 'leaf-lookers') convene from all over the world to witness this phenomenon. In all seasons, the park is enlivened with fast-flowing streams, rivers, waterfalls, and reflecting pools.

The open meadows at Cades Cove and the Cataloochee Valley are frequented by white-tailed deer in early morning and late evening. More than 400 bears roam the park and you are most likely to encounter them deep in the forest. Woodchucks are seen regularly along the roads.

The weather during spring and autumn is pleasant and warm with regular periods of rain and overcast skies. On rare occasions, there is autumn snow. For general information, maps, and specific dates of wildflower blooming and autumn color call ☎ 423 436 1200.

ACCESS AND ACCOMMODATION

Knoxville, Tennessee, where there are numerous car rental agencies (two-wheel drive is satisfactory), is the most convenient fly-in destination. Most visitors stay in one of the small towns outside the park. Of these, Gatlinburg and Pigeon Forge are the largest, providing scores of motels and eateries that cater to the tourist market. The villages of Cherokee and Townsend are smaller and quieter. There is one lodge within the park (LeConte Lodge, ☎ 423 429 5704, reservations necessary) that is accessible only by foot or horseback. There are ten developed campgrounds (no trailer hook-ups). Three of the

Above: I delayed the progress of this box turtle through a patch of wildflowers long enough to position my camera at ground level and equip it for close focusing. Canon T90, 100 mm macro Canon lens, Fujichrome Velvia, f/4 at 1/60 second. Right: I came upon this stand of birches in the early morning when the atmosphere was calm and not a leaf was stirring. This permitted a slow shutter speed and small aperture for maximum depth-of-field. Canon T90, 80-200 mm L Canon lens set at 200 mm, polarizing filter, Fujichrome Velvia, f/22 at one second.

campgrounds have disposal stations. Camping reservations are accepted from May 15 to October 30 at three of the sites (☎ 800 365 2267). The rest operate on a first-come, first-served basis.

SHOOTING STRATEGIES

With 290 kilometers (180 miles) of roads and 1,300 kilometers (800 miles) of hiking trails in Great Smoky Mountains National Park, you will have little trouble getting to and from shooting sites. Pick up a road guidebook at one of the visitor centers. From salamanders (a park specialty) to waterfalls to the world's largest hardwoods to mist-shrouded mountain ranges, you will encounter all manner of photographic subjects. Fish-eye, wide-angle, telephoto, and macro lenses will be useful. You will have little use for high-speed, action-stopping film. (The wildlife is difficult

to find and photograph due to the dense vegetation.) A fine-grained, saturated emulsion like Fujichrome Velvia is best for recording the color and texture of the great array of mostly inanimate subjects (even the salamanders move slowly).

Interesting photography awaits you anywhere in the park, but there are several sites you should be sure to investigate. For misty mountain landscapes, Clingman's Dome, the highest point in the park, cannot be beat at sunset or sunrise. A convenient place to photograph an abundance of spring wildflowers is at the Chimney's picnic area on Newfound Gap Road, south of the Sugarlands Visitor Center. Laurel Falls, reached by a 45-minute hike off the Little River Road, is one of the park's most photogenic water courses and a good place to shoot rhododendrons in late May. There are good sites for shooting cascades and rushing streams all along this road. Roaring Fork Road is excellent for wildflowers in spring, colorful foliage in autumn, and small waterfalls and quiet pools year-round. For the old-growth hardwood forests, for which the Smokies are famous, hike the Porters Flat Trail in the Greenbrier area, 10 kilometers (6 miles) east of the Sugarlands Visitor Center. The trail ascends slowly through stands of huge trees and patches of wildflowers in spring.

OTHER ATTRACTIONS

There is little need to venture outside the park for nature subjects. However, a special route for landscape pictures lies along the Blue Ridge Parkway. Known to some as the most scenic drive in America, this quiet, 756 kilometer (470 mile) byway follows the crest of the Appalachian mountain chain, from Smoky Mountains National Park to Shenandoah National Park in Virginia. This winding route has countless pull-outs and sideroads that overlook wide expanses of wilderness and farmland. The entrance to the parkway is one kilometer (0.6 mile) south of the Oconaluftee Visitor Center.

Above: The red-spotted newt, like other salamanders, inhabits damp woodlands near ponds and streams. They move infrequently, making them easy subjects for close-up photography. Canon T90, 100 mm Canon macro lens, 50 mm extension tube, Kodachrome 64, f/5.6 at 1/60 second. Left: I positioned the tripod-mounted camera as high as possible above this leaf-littered pond, and framed an area that showed the leaves running out of all sides of the frame to suggest their abundance. Canon T90, 24 mm Canon lens, polarizing filter, Fujichrome Velvia, f/11 at 1/15 second.

Alpine Reflections

Waterton Lakes National Park, Alberta
Spring through Autumn

Waterton Lakes National Park provides numerous opportunities for recording alpine reflections. These sites are concentrated within a small area of the park and are easily accessed by a good system of roads. This reflection was recorded inside the bison paddock in the late afternoon. Canon EOS A2, 28-105 mm Canon lens set at about 70 mm, polarizing filter, Cokin graduated neutral density filter, Ektachrome EPP 100, f/11 at 1/30 second.

WATERTON LAKES NATIONAL Park is one of the best locations in North America to photograph mirror-like reflections of alpine landscapes. It also provides opportunities for photographing wildlife as good as Yellowstone or the Grand Tetons, but without the crowds. This nature photography mecca is primarily the result of the park's unique topography. At Waterton, the rich, rolling grasslands of Alberta end abruptly as they encounter the 1,200 meter (4,000 foot) wall of the Rocky Mountains, bringing together the flora and fauna of two different ecosystems. Although Waterton's adjoining sister park in Montana, Glacier National Park, is larger and has more lakes and higher mountains, it offers fewer photographic opportunities.

In Waterton, meltwater from high country snowpacks creates lakes, ponds, and marshes in the parkland terrain at the foot of soaring, glaciated mountains. The east-flanking prairie and lack of a closed forest allows early morning light to illuminate lake surfaces. You can set up for photography just about anywhere you find a suitable reflection. The prairie habitat allows you to spot wildlife easily and photograph relatively tame moose, mule deer, wapiti, bighorn sheep, coyote, and black bear in full sunlight rather than in the shaded setting of a forest. In addition to big game species and mountain reflections, wildflowers are abundant during the warmer seasons.

Each season has its special attraction. Spring

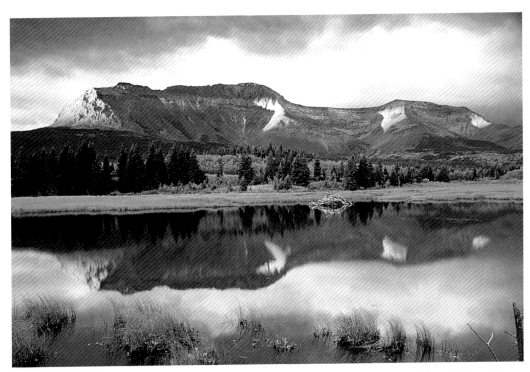

Above: I came upon this reflection of a beaver lodge and snow-capped peaks in the backwaters of the Blakiston River. Like most reflections, it lasted only a few minutes, vanishing with the day's first breezes. Left: There are numerous sites along the Big Chief Mountain Highway leading out of the park to the south where good reflections can be found, especially in the early morning when the peaks catch the rays of the rising sun.

is announced by waves of migrating waterfowl and the bloom of prairie wildflowers at lower elevations. Summer is a period of sunny, calm weather—the best time for shooting reflections, alpine wildflowers, and moose feeding on pondweeds in the lakes. With fall comes the golden foliage of aspen groves, the southward migration of even greater numbers of birds, the arrival of over-wintering elk herds, and the appearance of black bears feeding on berries and choke cherries in the valleys. The severe winters are relieved periodically by warm chinook winds that clear away the prairie snows and make life easier for foraging elk, mule deer, pronghorn antelope, and bighorn sheep. Unfortunately, it is rarely warm enough for the lakes to melt and make reflection photography of the alpine landscapes possible.

As in any alpine habitat, Waterton's weather can change rapidly and you should be prepared for cold temperatures and precipitation at any time of year. In winter the mountains receive up to five meters (16 feet) of snow.

ACCESS AND ACCOMMODATION

To reach Waterton Lakes Park (information ☎ 403 859 2224), you can fly into either Kalispell, Montana or Calgary, Alberta, both of which have plenty of car rental facilities (two-wheel drive is sufficient) and are only a few hours' drive from the park. There are numerous motels and hotels in Waterton Park Townsite in a variety of price ranges (reservations ☎ 403 859 2203), and a good selection of restaurants and grocery stores. There are three main campsites with tables, firewood,

Elk, mule deer, and coyotes are often seen near the main road that runs along Lower Waterton Lake. This mule deer buck was grazing on a hillside among sunflowers in the late afternoon. Accustomed to hikers, it was not alarmed when I moved cautiously into position to photograph it against the shaded hillside. Canon EOS A2, 400 mm L Canon lens, 1.4X teleconverter, Fujichrome Velvia, maximum aperture at 1/250 second.

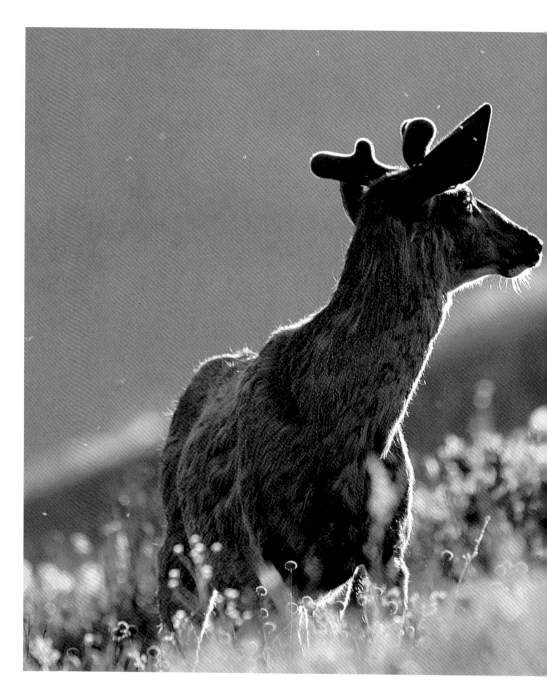

washrooms, and water. The townsite campground has full trailer hook-ups.

SHOOTING STRATEGIES

When photographing reflections, it is critical that the water surface be still. A whisper of wind is enough to ruin a beautiful composition. The best chances for mirror-sharp reflections are at sunrise and, less frequently, at sunset. Waterton is known for its wind, but summers are usually calm. Decide a day in advance exactly where you plan to set up for shooting and arrive well before sunrise or sunset. When photo-

graphing reflections, you can dramatize the reflected effect by placing a graduated neutral density filter over the sky and landscape portion of the scene (not the reflection), which brings both halves of the composition into almost equal levels of luminance.

Aside from the obvious Waterton Lakes locations, there are also good reflections in the backwaters of the Belly River along the Big Chief Mountain Highway.

OTHER ATTRACTIONS

You will want to photograph the attractions in adjoining Glacier National Park, known for its ice fields, its concentration of wildlife in the Many Glacier area, and the 'Going-to-the-Sun Road', a spectacular mountain route that traverses the park above timberline.

The Going-to-the-Sun Road in Glacier National Park has overlooks where you can photograph a variety of mountain scenes. This abstract composition was shot above timberline across a broad valley. The clear mountain air permitted detailed resolution despite the distance. Canon EOS A2, 70-200 mm L Canon set at 200 mm, 1.4X teleconverter, polarizing filter, Fujichrome Velvia, f/4 at 1/125 second.

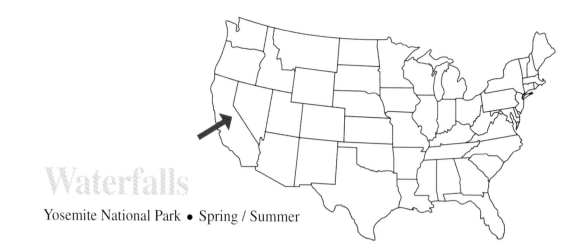

Waterfalls

Yosemite National Park • Spring / Summer

YOSEMITE NATIONAL PARK is best known for its waterfalls streaming over vertical cliffs 600 meters (2,000 feet) high. The nucleus of the park is Yosemite valley, 11 kilometers (7 miles) long, characterized by towering walls of naked granite and a flat floor of still pools, open meadows, flowering shrubs, oak woodlands, and forests of ponderosa pine, incense cedar, and Douglas-fir. Waterfalls surrounding the valley's immense perimeter blast over the rim of the canyon and drop in an eerie, slow-motion roar to the valley floor. The major waterfalls— Yosemite, Bridalveil, Vernal, and Nevada—reach maximum flow in May and June. By mid-August they may have little or no water.

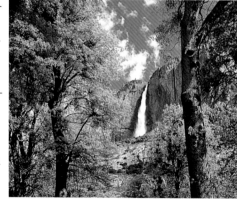

There are numerous other attractions in this 3,000 square kilometers (1,200 square miles) of wilderness, including fast flowing streams, shining lakes, and massive monoliths with names that suit their grandeur—Half Dome, El Capitán, and Cathedral Rocks. The park is dominated by alpine habitat, punctuated by 4,000 meter (13,000 foot) peaks and strewn with colorful wildflowers in summer. Between the elevations of 1,400 and 2,200 meters (4,500 and 7,500 feet) are groves of giant sequoias with reddish buttressed trunks six to nine meters (20 to 30 feet) in diameter and more than 75 meters (250 feet) high. Wildlife in the park is abundant and varied due to the multitude of habitats.

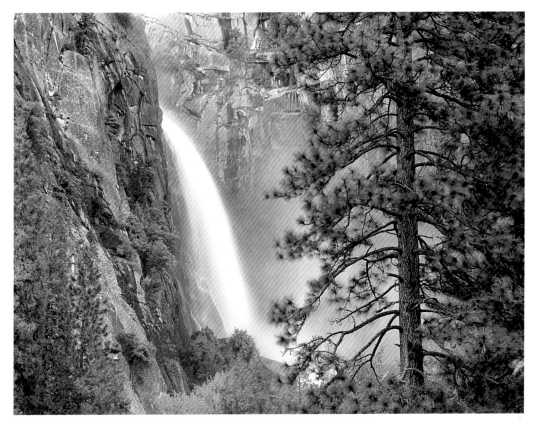

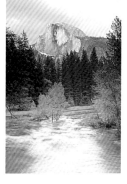

Left: Waterfalls are best photographed under cloudy skies when soft light illuminates the scene evenly, allowing both shadows and highlights to fall within the film's exposure range. Good detail and saturated color are evident in both the trees and flowing water. Below: Half Dome, like other of Yosemite's famous landmarks, appears most dramatic when photographed early or late in the day when the light is soft and the sky is likely to be rich in color.

Yosemite offers spectacular scenic photography at any time of year. The waterfalls run strongest during April and May. In June and July the cascades are much diminished, but this makes it possible to get closer without soaking yourself and your equipment. The weather during spring and summer is temperate, with frequent rain and overcast skies.

ACCESS AND ACCOMMODATION

In the spring you must enter Yosemite from the vicinity of Fresno, California to the south and from the San Francisco area to the west. Both cities have regular air service and car rental facilities

(two-wheel drive is adequate). By June the snow blocking Tioga Pass has melted and the eastern entrance is open. If you take this route, you will pass by two photographic attractions on the way to the waterfalls—Mono Lake just outside the park, known for its bizarre tufa formations and dramatic sunsets, and the alpine meadows inside the park at Tuolumne.

Lodgings, restaurants, and stores are available at Yosemite Valley, Wawona, and El Portal year-round, and at Tuolumne Meadows and White Wolf during summer. Make reservations as far in advance as possible (☎ 209 252 4848). Partial service campgrounds—with tables, toilets, and water but no

utilities for motor homes, are located throughout the park, but only those at Yosemite Valley, Wawona, and Hodgdon Meadow are open year-round. Reservations are required at least two months in advance (☎ 800 436 7275). There are several motels and restaurants just outside the Arch Rock entrance at El Portal. These are within easy driving distance of the waterfall area. Call the park in advance for information and maps (☎ 209 372 0200).

SHOOTING STRATEGIES

Most of the waterfalls are found in Yosemite Valley. This area is braided with roads and it is only a short walk to most shooting sites. (It is difficult to find parking on weekends.) With luck, rainy weather will accompany your visit. Not only does the rain drive out many of the tourists, but overcast skies are essential for photographing waterfalls. The movement of water is accentuated when it is contrasted with stationary elements in the composition. Rocks, while part of every waterfall, are inadequate for static reference. They do not express the scale of a scene (big rocks and small rocks look the same) as effectively as do trees, shrubs, or wildflowers which should be incorporated into your compositions. To bring out the color and detail of these key floral elements, shoot in low-contrast light. The rushing water will appear more attractive if you blur it by using a shutter speed of 1/15 second or longer.

Numerous trails, which you may explore for photographic views, lead to and from all the major waterfalls. It is usually a waste of time to hike to the top of any of the waterfalls, because the elevated camera angle does not convey the power and elegance of the streaming water or its relationship to the landscape.

On sunny days, contrast is too great for slide film to record both the texture of foaming water and the color of the surrounding foliage. If skies are fair, set aside the waterfalls and work with the concentration of alpine peaks and massive granite facades that line the valley, limiting your shooting to the periods of sunrise and sunset.

You are likely to be overwhelmed by the breathtaking scenes that confront you at nearly every turn along

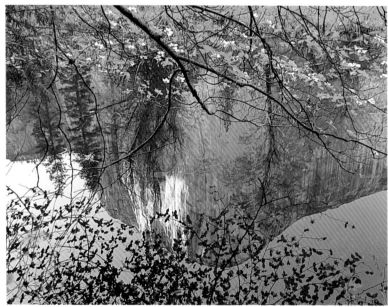

Explore Yosemite Valley for unusual views of familiar landmarks. I found this reflection of flowering dogwood and El Capitan in a bottomland thicket temporarily flooded by spring rains. Canon EOS A2, 20 mm Canon lens, Fujichrome Velvia, f/8 at 1/15 second.

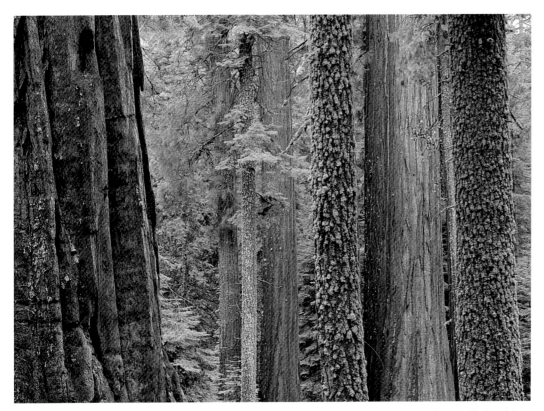

the valley highway. Resist making hurried photographs of these famous views, most of which you have probably seen on postcards and calendars. Instead, you might begin by making a careful evaluation of the area, considering pictorial factors such as foregrounds, ambient light conditions, perspective cues, and reflections. Then schedule your shooting to work with only one site for each period of sunset or sunrise. Be aware of unusual elements that might be incorporated into compositions featuring recognizable landmarks like El Capitan or Half Dome. Unpredictable atmospheric effects play briefly across the rock faces and cloud banks when the light is low. These may often become the strongest and most distinguishing aspects of your imagery.

Use a saturated, fine-grained, low ISO film like Fujichrome Velvia for all of your shooting here. Polarizing and graduated neutral density filters and lenses from fish-eye to moderate telephoto focal lengths will be useful.

OTHER ATTRACTIONS

You shouldn't leave Yosemite without photographing the giant sequoia groves—especially those at Mariposa Grove, 56 kilometers (35 miles) south of Yosemite valley.

Rock Canyons

Grand Canyon National Park • All Year

The Grand Canyon's north rim (right) is isolated and visited by relatively few tourists. Although it does not provide as many opportunities for spectacular images as the south rim, the smaller crowds here make photography more pleasant.

THE GRAND CANYON IN Arizona provides three key elements for artistic scenic photography: strong color, deep perspective, and dramatic skies. The canyon itself is among the geologic wonders of the world. Nowhere else can you look so deeply into the earth's crust—some 900 meters (3,000 feet). The park encompasses four eco-zones, ranging from desert to moist coniferous forest. Inhabiting the rim and sheer rock walls are hundreds of vertebrate species, including mountain lion, coyote, mule deer, bighorn sheep, beaver, turkey vulture, various humming-birds, chuckwallas, and rattlesnakes. At the bottom of the canyon, the Colorado River is lined with willows, cottonwoods, mesquite, varied cacti,

agave, yucca, and ocotillo. The arid South Rim has stunted clumps of piñon pine and juniper and tall stands of ponderosa pine set back from the rim. The North Rim, 300 meters (1,000 feet) higher than the South Rim, has more rainfall and better soil which nourishes luxuriant forests of spruce, fir, as-pen, and ponderosa and yellow pine. Wildflowers bloom everywhere through spring, summer, and fall.

Despite the variety and abundance of wild-life, the primary attraction for photographers is the incredible landscape. The Colorado river has cut through two billion years of rock strata, exposing multi-hued layers of metamorphic and sedimentary rock. The canyon has an east-west orientation which allows both the

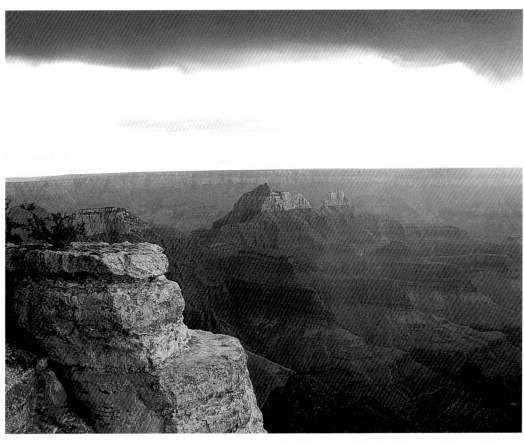

Left: I took this photograph at Bright Angel Point on the canyon's north rim. It was near sundown after a thunderstorm when the sky was full of warm hues and the color of the rocks was enriched by recent showers. Canon EOS A2, 70-200 mm Canon lens set at about 70 mm, polarizing filter, Cokin graduated neutral density filter, Fujichrome Velvia, f/8 at 1/4 second. Below: This view of the south rim was taken in late winter when snow dusted the edge of the cliffs, its neutral color accentuating the rich color of the rocks.

rising and setting sun to illuminate its cavernous interior. The color deepens after a rain, one of the best times for photography. In summertime, warm air rising from the depths of the canyon forms towering thunderheads that douse the landscape and create sensational atmospheric effects. In wintertime, snow lies in thin blankets over the rocks, establishing a neutral reference against which the rocks' color can be fully appreciated.

The Grand Canyon's climate is temperate. Heavy snows close the North Rim from mid-November to mid-May. The North Rim is generally 6°C (10°F) cooler than the South Rim, which is 17°C (30°F) cooler than the canyon bottom. There are regular afternoon showers during the summer and early fall.

ACCESS AND ACCOMMODATION

Flagstaff is the closest city with scheduled air service and car rental agencies (two-wheel drive is adequate). From here it is a two hour drive to park headquarters at Grand Canyon Village on the South Rim, which hosts nine times as many visitors as the North Rim. There are lodges on the canyon rim and

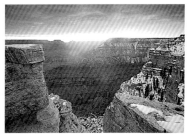

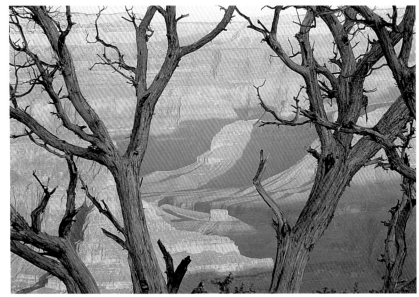

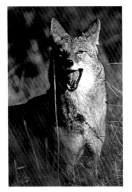

Right: Look for elements in the landscape that can accentuate the canyon's deep perspective, such as this juniper tree. I came across the tree late in the day and returned the next morning when the rising sun illuminated it and the canyon's interior equally. Canon T90, 80-200 mm L Canon lens, Fujichrome 50, f/16 at 1/15 second. Below: This coyote, like most wildlife in national parks, was used to close contact with humans, making it a relative easy subject for photography. Canon T90, 500 mm L Canon lens, Kodachrome 64, f/4.5 at 1/250 second.

at Phantom Ranch at the canyon bottom. Reservations are necessary, especially during summer (☎ 303 297 2757 for all lodges and campgrounds in the park). There are also two full-service campgrounds and a trailer park with hook-ups which require reservations during summer. Space in one of the campgrounds is allotted on a first-come, first-served basis. It's another three hours of driving to reach the isolated North Rim, where there is a lodge and National Forest and National Park campgrounds. Lodgings in the small towns outside the park are few and too far from the best photography sites for convenient shooting. There are gas stations and stores on both rims.

Shooting Strategies

The South Rim has the most shooting sites and provides the most productive photography. If skies are clear, you will have about 30 minutes before and after sunrise to shoot before the light becomes too stark and colorless to capture the subtle hues of the sky and canyon walls. Scout out your camera positions in advance and be ready to start shooting at least half an hour before sunrise.

Approaching sunset, there frequently will be clouds to soften and add color to the ambient light conditions, extending the shooting period. Some of the best light occurs for about 15 minutes after sunset, when light is subtly reflected onto the landscape from the undersurface of the clouds.

To create a feeling of deep perspective, look for shooting sites with strong foreground elements—such as a tree or rock formation—that you can use to frame the canyon. The top of the canyon is flat, making it ideal for using a graduated neutral density filter to darken the sky and bring it into the same exposure range as the canyon itself (ideally within one or two stops).

The canyon rim rises at a slight angle from south to north. If you record it exactly as it is, it will result in a horizon that seems tilted—as though you did not have the camera leveled properly. For artistic reasons, you may wish to 'straighten' the canyon in some situations. Wide-angle to moderate telephoto lenses will be most

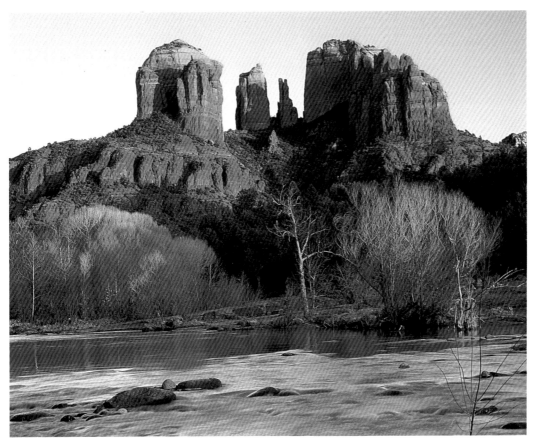

Left: Another area of spectacular rock formations of great size and vivid color is found a short drive south of Flagstaff at Sedona, Arizona. Unfortunately, many of the natural scenes are spoiled for photography by human development. Below: Although the landforms of the Painted Desert cannot match the grandeur of the Grand Canyon, its rocks are more colorful.

useful. Low ISO, saturated films and a polarizing filter will accentuate the canyon's colors.

OTHER ATTRACTIONS

About a half-hour drive south of Flagstaff on State Highway 179, you will find the small town of Sedona, Arizona nestled amid an amazing concentration of red rock mountains and giant boulders. There are plenty of motels and restaurants here.

A series of beautiful, blue-green waterfalls is found on the Havasupai Indian Reservation on the south side of the Colorado River, 55 kilometers (33 miles) northwest of Grand Canyon Village. You can camp or stay at the lodge in the village of Supai, which is a short walk from the falls. Reservations are necessary (☎ 520 448 2111). There is a cafe that serves three meals a day and a small store. The area is 13 kilometers (eight miles) from the nearest road and is only accessible by foot or horseback. The Havasupai Indians supply horses and guide service.

Autumn Color

Eastern Vermont • September / October

Uncluttered landscapes like this fiery hillside are common in eastern Vermont. Shooting is better in the latter part of the autumn color season when there is increased chance of snowfall and the reduced foliage on trees allows more open views into the forests. Canon T90, 300 mm L Canon lens, polarizing filter, Fujichrome 100, f/8 at 1/125 second

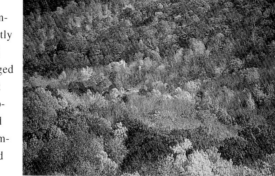

NEW ENGLAND IS KNOWN for its spectacular fall color, and Vermont best captures the region's glory. So well preserved is this state, it projects the aura of a giant national park. Highways (along which roadside advertising is prohibited) are mostly winding, two-lane routes passing through peaceful mountain forests, interrupted infrequently by small farms and villages little changed throughout the past century. White clapboard churches, red barns, rambling cemeteries, and covered bridges make up quaint settlements that seduce photographers. Forests are composed of species which produce especially brilliant color in autumn—maple, birch, beech, oak, and hickory. Colors first change in the north and at higher elevations, then proceed southward into the valleys. The show begins in earnest about mid-September and reaches its peak during the first or second week of October. It is best to arrive later in the season, rather than earlier, for several reasons. With the progression of autumn, chances increase of an early snowfall, which dramatizes leaf color. With fewer leaves on the trees, views open up into the forest, providing better opportunities to show perspective. Driving is more pleasant because tourist congestion on highways is less.

The two best areas in Vermont for color are the southern part of the state between the Connecticut River and Route 100 (near the New Hampshire state line), and in the north along the Connecticut River. Be pre-

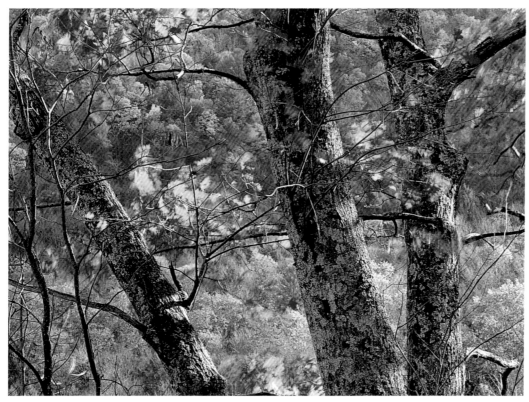

Above: Freezing temperatures produce a wealth of macro-subjects on the forest floor, such as this frosted leaf and dogwood berry. Be sure to take close-up accessories. Canon T90, 100 mm Canon macro lens, Fujichrome Velvia, f/11 at 1/8 second. Left: I selected a slow shutter speed to blur the wind-tossed foliage of this sycamore tree and positioned the depth-of-field zone to include both the tree and the hillside in the background. Canon EOS A2, 28-105 Canon lens set at about 105 mm, polarizing filter, Fujichrome Velvia, f/22 at one second.

pared for cool temperatures with mixed skies, rain likely, and snow possible.

ACCESS AND ACCOMMODATION

The most convenient, major fly-in destination with numerous car rental agencies (two-wheel drive is adequate) is Hartford, Connecticut, about a 90 minute drive from Brattleboro, Vermont, which is a good place to spend your first night. Although there are abundant accommodations, including bed-and-breakfasts, small inns, and hotels, most of the popular lodgings are booked by the end of summer for 'leaf peeper' season. No matter—as a photographer, you will want to stay in lodgings near the areas of peak color. This is not always easy to predict. It is best to find your shooting sites first, then book a room to your liking. If you settle this matter by noon each day, you should not have any problems.

SHOOTING STRATEGIES

The name of the autumn foliage game is color—brilliant warm color—and there are several techniques you can employ to make the most of it. Use a polarizing filter to eliminate shine from the leaves, allowing the leaf's color to register fully on the film. Use a fine-grained, saturated film like Kodachrome 25 or Fujichrome Velvia and your images will appear vibrant and natural. The warm colors of the landscape will be heightened if set

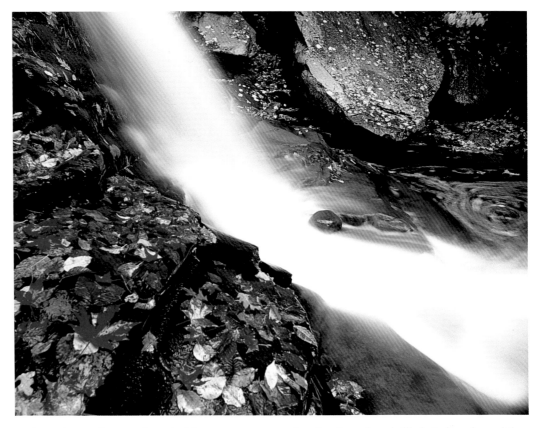

Three key elements are required for making effective moving-water photographs. The sky should be overcast or hazy to reduce contrast in the subject. Colorful, motionless vegetation should be incorporated into the composition. A shutter speed of 1/15 second or slower should be used. (If ambient light is too strong to allow long exposures, employ neutral density filters.)

against colors at the opposite end of the spectrum—the blue of the sky or the green of conifers. Warming filters and color enhancing filters are not recommended; warming filters create a color cast and enhancing filters cause a color shift.

When shooting distant scenics in the early morning with a polarizing filter and slow film (ISO 50 or less), use an aperture that will allow a shutter speed of 1/125 second or faster. Although you may not notice the foliage rustling in the wind in the viewfinder, it will register on film nevertheless and result in softened detail. As usual, it is best to shoot early or late in the day when the atmosphere is likely to be calm and the ambient light low in contrast and rich in color.

OTHER ATTRACTIONS

In addition to forests and foliage, there are many streams and waterfalls in this upland region that you may wish to photograph. For non-purists, there are beautiful pastoral scenes of grazing horses and cattle, bailed hay, covered bridges, steepled churches, and tree-shaded village commons.

Small Treasures

Columbines & Hummingbirds

Yankee Boy Basin, Colorado • Summer

Yankee Boy Basin, nestled among high scenic peaks, receives ample moisture from snowpack run-off that encourages the growth of wildflowers. The mountains shelter the meadows from wind, making long exposures possible even during mid-day.

THIS SMALL VALLEY in the San Juan Mountains of southwestern Colorado is above timberline, surrounded by snow-capped peaks, dotted with blue lakes and pools, and laced with streams and waterfalls. During July, wildflowers thrive in the basin's rich, moist soils. The plants and animals here must pack a full year's worth of living into the few weeks of the alpine summer. Even before snow disappears from the slopes, the first glacier lilies have appeared, signaling the main rush of wildflowers that follows. By mid-July the basin is overgrown with paintbrushes, lupines, sneezeweeds, hellebores, marsh marigolds, bluebells, and thick clumps of Colorado columbines—the most beautiful of alpine species. Wildflowers appear first at lower

elevations and on south-facing slopes, then creep upward and northward as the season progresses.

The rush of vegetative growth provides sustenance for a number of photogenic alpine creatures: black bears, mule deer, pikas, ground squirrels, white-crowned sparrows, and hummingbirds to mention only the more readily viewed species. The alpine landscapes are spectacular in every direction and as worthy of photographic attention as the flowers and wildlife.

Lingering snowpacks keep visitors out of the basin until July, with the latter part of the month providing the best show of blooms. The days are usually a mixture of cloud and sun, with temperatures rising to shirt-sleeve levels by mid-morning.

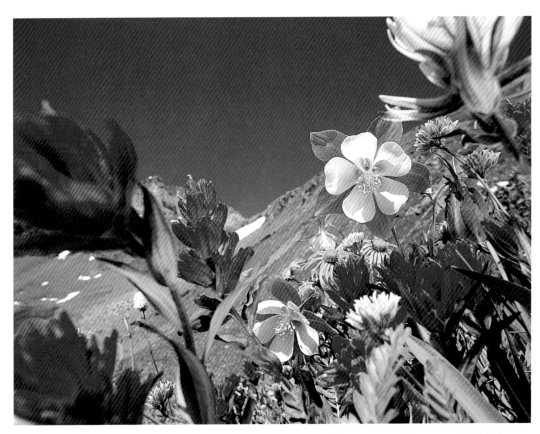

I like to devise compositions which include flowers as well as the spectacular alpine setting. Here, I used a wide-angle lens and placed the camera within a few inches of a thick growth of blooms. A reflector positioned on the ground lit up the under-surface of the vegetation. Canon EOS A2, 20 mm Canon lens, polarizing filter, Fujichrome Velvia, f/11 at 1/15 second.

Be prepared for cold nights (to near freezing) and possible snow showers.

ACCESS AND ACCOMMODATION

Durango, Colorado, a thriving tourist center, offers the closest jetport to Yankee Boy Basin. Here you can rent a car (four-wheel drive is necessary) and proceed 115 kilometers (70 miles) to the picturesque town of Ouray. This drive follows the 'million-dollar highway', a route that winds through several high passes of the San Juan Mountain wilderness. Most visitors to Yankee Boy Basin stay in Ouray, which is nestled among high peaks, has a good choice of restaurants, and

plenty of places to stay. Rooms are in high demand during summer so it is best to check in early in the afternoon.

You can camp at the Uncompahgre National Forest campground about a mile southeast of Ouray, where there are fire pits, pit toilets, tables, and drinking water. Open camping is also permitted in Yankee Boy Basin. Although this area is without facilities and is much colder than the national forest campground, it's more fun to set up tents in the basin, right beside the scenic meadows.

From Ouray it takes about a half-hour to drive to the basin on a rough, four-wheel drive road

which starts just south of town off Route 550. Take the turn-off to Box Canyon Falls, keep left when you reach the first fork, and proceed on this track until you reach the basin. If you have two-wheel drive, you can catch one of the jeep tours that depart frequently from Ouray. You will probably wish to stay out shooting longer than the rest of the group, so make arrangements to come back on a later jeep. It is sometimes possible to reach the meadows in a two-wheel drive pick-up truck. (I have done it several times in a rented sports car.)

SHOOTING STRATEGIES

The surrounding mountains keep the basin in shade until well after sunrise, so be prepared to deal with high contrast ambient light. For close-up photography, I carry a collapsible reflector to bounce light into the shadow side of the scene. For wider views I use on-camera fill flash set at about 1.5 stops less than the ambient light exposure. I may also soften the strobe light by fixing a thin layer of white cloth over the reflector or attaching a Lumiquest Pocket Bouncer to the flash.

The brilliant color of alpine meadows calls for a fine-grained, saturated film with a low ISO rating, such as Fujichrome Velvia or Kodachrome 25. At high elevations conditions may be surprisingly calm on clear days, permitting exposure times up to 1/15 second without wind blur—provided shots are taken between breezes. A cable or electric shutter release is essential in such situations, not only to prevent vibration-free exposures, but also to permit you to keep your finger on the trigger while waiting for the next atmospheric lull. I like to fill up as much of the foreground as possible with blooms, letting distant mountains show through gaps in the vegetation. To do this I lay on the ground and prop the camera up with a beanbag or a few small rocks gathered from around the site.

Any focal length lens will be useful. A macro-zoom in the 35-100 mm range allows a wide variety of effects, from close-up studies to full scenics. I usually attach a polarizing filter to darken skies and reduce reflections from the waxy surface of the blossoms, which produces more color saturation.

To photograph hummingbirds, lenses in the 500 mm and longer range, equipped with an extension tube for close focusing, are required. Hummingbirds are constantly on the move, but each bird has a few favored bouquets that it visits regularly every ten minutes or so. Set up the camera where you have a few such sites within range and bide your time.

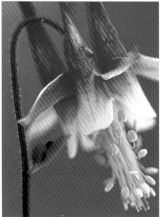

Hummingbirds visit clumps of flowers at regular intervals. You can learn an individual's habits in about an hour of careful observation. Males perch on taller flowers as a way of indicating their territorial claims. To photograph this broad-tailed hummingbird, I used a camera that permits flash synchronization at any shutter speed. This enabled simultaneous use of a stop-action shutter speed (set for the ambient light level) and fill-in flash. Canon EOS Elan II, 400 mm L Canon lens, 50 mm extension tube, Canon Speedlite 380EX, Ektachrome EPP 100, f/2.8 at 1/2000 second.

OTHER ATTRACTIONS

Yankee Boy Basin lies in the heart of four-wheel drive country, allowing photographers to access remote alpine regions for recording both landscapes and wildlife. There are hundreds of miles of high country jeep trails in the vicinity of Telluride, Silverton, and Ouray that you could spend summer after summer exploring. Detailed maps of the back country are sold in most book stores and outdoor outfitting shops in the region.

Accommodations for tourists are diverse and abundant. Many of the national forest areas offer open camping. The region is equally attractive in autumn, when aspen groves light up the mountain-sides with the golden glow of turned foliage.

Shooting upward against this steep hillside placed the meadow against the darkest, most saturated part of the sky. Canon EOS A2, 70-200 mm L Canon lens set at 200 mm, Fujichrome Velvia, f/13 at 1/60 second.

Cacti & Jackrabbits

Big Bend National Park, Texas • March / April

The Chisos Mountains dominate the topography of Big Bend National Park. Taken at sunrise midway along the road connecting Castolon and the Santa Elena Canyon, this photograph exhibits a compressed perspective due to use of a telephoto lens. A 2-stop graduated neutral density filter was used to reduce the brilliance of the upper region of the composition. Canon T90, 100-300 mm L Canon lens set at 300 mm, 1.4X teleconverter, Fujichrome Velvia, f/8 at 1/4 second.

BIG BEND NATIONAL PARK'S isolated location in the desert wilderness of southwestern Texas makes it one of the least known American parks. If your goal is to escape civilization and work where there are few other photographers, this is the place to do it—provided you refrain from visiting the park on a national holiday. Elevations in the park range from 550 to 1,800 meters (1,800 to 6,000 feet), resulting in diverse vegetation zones of more than 1,000 plant species. Among them are wildflowers, cacti, yuccas, ocotillos, and creosote bush in the lowlands; piñon, juniper, and oak associations at mid-elevations; and mixed forests of Douglas-fir, ponderosa

pine, and quaking aspen on mountain tops and ridges. Acacias, cottonwoods, willows, and saltcedar crowd the arroyos and river bottoms.

The cactus species are typical of the Chihuahuan desert habitat and vary in size from the button cactus, which you could cover with one hand, to stands of prickly pear that spread over many acres. When in bloom, strawberry, hedgehog, and claret cup cacti are among the more striking species, most of which flower in March and April.

The park's habitats support an equally varied fauna. At your feet are many desert specialties for close-up work: tarantulas, scorpions, grasshop-

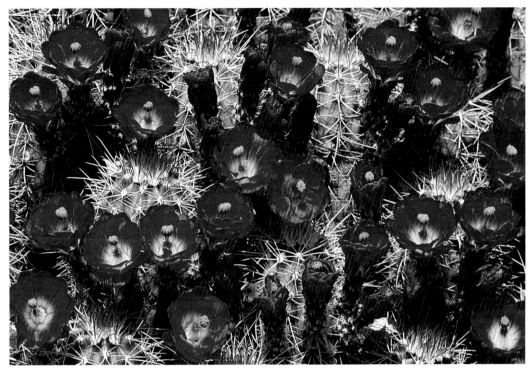

pers, and more than fifty kinds of snakes and lizards—including rattlesnakes, coachwhip snakes, and horned toads. Larger common vertebrates that you are likely to see are the mule deer, javelina, coyote, and black-tailed jackrabbit. Hundreds of bird species are found in the area, including the greater roadrunner, Lucifer hummingbird, golden eagle, painted bunting, and vermilion flycatcher.

The rugged Chisos and Sierra del Carmen mountains, undulating desert flatlands, and carved river canyons offer unending possibilities for scenic photography. There are no nearby attractions for nature photography outside the park.

In March and April the weather in Big Bend is pleasant, with warm, sunny days and cool, starry nights. Rain is unlikely; annual precipitation in lowland areas is less than 10 centimeters (4 inches) per year.

ACCESS AND ACCOMMODATION

Airlines service Midland-Odessa and El Paso, Texas, both about a half-day's drive from the park headquarters. In either city you will find ample car rental agencies (two-wheel drive is adequate).

Inside Big Bend National Park (☎ 915 477 2251, ext.158, for maps and information), accomodation is available in Basin at the Chisos Mountain Lodge. Camping is permitted at three different locations. The Cottonwood campground is the most quiet and secluded. Utility hook-ups are available at Rio Grande Village campground. All of the campgrounds have tables, pit toilets,

A macro photograph is often meant to show detail that is missed by casual observation, making the use of a tripod important to the picture's success. A tripod steadies the camera and permits great depth-of-field by allowing the use of slow shutter speeds and small apertures. The hard light of the desert can be softened by using reflectors (cactus photographs), or avoided by using back-light (greater roadrunner photograph).

Above: Horned toads are one of the many reptile species found at Big Bend. Right: I moved cautiously around this jackrabbit until it was lit from behind in order to show the sun shining through the thin skin and fur of the jackrabbit's trademark ears. In such situations, exposure can be set by taking an average reading of the scene, or reduced from this value by 1/2 stop. Canon T90, 500 mm L Canon lens, Fujichrome Velvia, f/4.5 at 1/125 second.

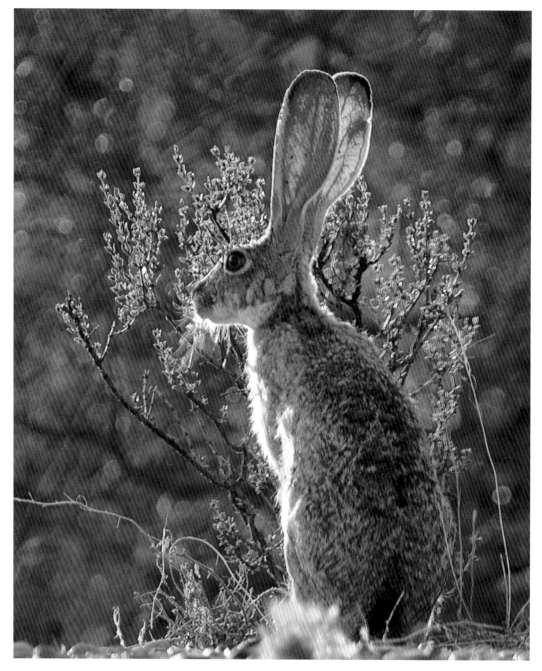

fire pits, drinking water, and nearby grocery stores. Reservations are necessary in the spring and fall for the developed campsites and lodging facilities (☎ 915 477 2291). There also are numerous primitive campsites found throughout the park.

This photograph is a composite of two slides—a juniper tree silhouette sandwiched with an image of the sky. The stars were photographed with the camera mounted on an equatorial star-tracker which compensates for the turning of the earth to keep the camera fixed on the area of the sky originally framed. This enables sharp images even with exposure times of several hours. Canon T90, 50 mm Canon lens, Fujichrome Velvia, f/1.8 at one hour (star image only).

SHOOTING STRATEGIES

The high contrast light, which is common in this cloudless environment, presents the greatest technical challenge to photographers. In such conditions, I use several approaches for photographing small subjects like cacti. I shoot early or late in the day, setting up a white reflector to bounce light into the shadows. I also use on-camera, fill-in flash or shade the subject with a layer of white cheesecloth. With the latter method I add a warming filter to balance the main source of illumination—the blue sky. If there are clouds, I wait until one passes in front of the sun.

As in most national parks, the wildlife in Big Bend is easily approached, particularly in the vicinity of the campsites. Jackrabbits can be readily photographed with a lens of 500 mm or more at Castolon, near the Cottonwood campsite, where they come to drink at the leaky faucets behind the ranger station late in the day.

At sunrise you will find spectacular views of mountains wrapped in mist along the road between Castolon and the Santa Elena Canyon overlook. Another scenic hotspot at sunrise is Window Rock, a half-hour hike along the trail which begins a mile from the end of Grapevine Hills Road.

OTHER ATTRACTIONS

Clear skies, low humidity, and a remote location make Big Bend an ideal site for photographing the heavens. You can set up a tripod-mounted camera in front of your tent or motor home, and photograph star trails all night long. Using a fine-grained, low ISO speed film, exposures may vary between one and several hours at f/4 or f/5.6. The wider the lens focal length, and the more the camera is angled toward the north, the smaller the radii of the arcs will be. Photograph the stars through the limbs of a tree, a rock formation, or other natural, stationary element to accentuate the symetrical sweep of the trails.

California Poppies

Antelope Valley, California • April

The Antelope Valley is popular with tourists, especially on weekends, when they descend en masse on the California Poppy Reserve State Park (right). Fortunately, there are numerous uncrowded areas in the vicinity, many of them better for photography.

SURELY THE MOST eye-catching displays of wildflowers anywhere in the world are those found in the Antelope Valley of California. Its flowering meadows, dominated by glowing, densely packed bouquets of poppies, are spread over an open, rolling, sun-drenched countryside. The eye can take in much in a single sweep—flowers seemingly held up for view by the tilting landscape, and green hillsides splashed with orange and framed by deep blue skies. Here you

can train your lens on the delicate forms of individual blossoms as well as the sweeping patterns and perspectives of a concert of hundreds of thousands of blooms.

Antelope Valley boasts no great concentrations of wildlife, but the gently sculpted countryside, dotted with oak groves, provides interesting material for pastoral scenics.

A good poppy crop is dependent upon abundant rainfall the preceding winter and plenty of warmth and sunshine in spring. The bloom usually peaks about the middle of April. Phone the California Poppy Reserve (☎ 805 724 1180) for a current report and/or a forecast of conditions to help in timing your shoot. The weather in southern California at this time of year is generally warm and sunny.

ACCESS AND ACCOMMODATIONS

You can fly into any of the airports in the Los

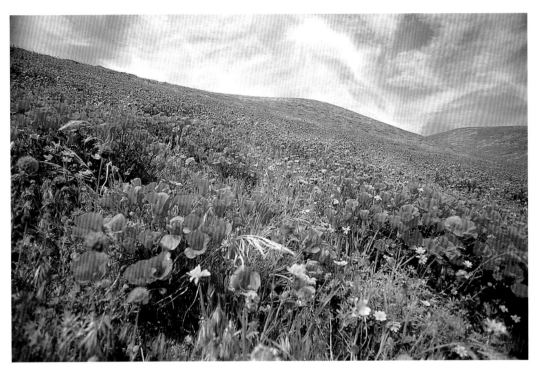

Left: The full depth-of-field in this meadow scenic was made possible by the tilted landscape, which brought the picture elements into closer alignment with the film plane. Canon T90, 20 mm Canon lens, Fujichrome Velvia, polarizing filter, f/11 at 1/15 second. Below: The limited depth-of-field in this poppy portrait resulted from high magnification and setting the lens at maximum aperture. Canon EOS A2, 500 mm L Canon lens, 50 mm extension tube, Fujichrome Velvia, f/4.5 at 1/125 second.

Angeles area and be only an hour or so away by car from the poppy meadows. To reach Antelope Valley from the south, follow Interstate 5 from Los Angeles and exit on State Highway 138, a few miles before the tiny settlement of Gorman. From the east, travel north on U.S. Route 395 and follow State Highway 138 west. There are three reliable areas that you should check: California Poppy Reserve State Park (jammed with traffic on weekends), the Tehachapi Mountains east of Gorman, and Gorman itself, which presents some of the most impressive displays within view of Interstate 5.

Accommodations in this area are scarce. Luckily there is one acceptable motel in Gorman (the largest building in town), which is within walking distance of some nice meadows. Reservations are not necessary. Gorman also has several eateries, a gas station, and

little else. There are two campgrounds a few miles south off Interstate 5 at Pyramid Lake and Hungry Valley.

SHOOTING STRATEGIES

Timing is a critical aspect of successful poppy photography. The atmosphere is most calm first thing in the morning, allowing you to make long exposures at small apertures (for great depth-of-field) without worrying about the wind causing the flowers to blur. The poppy blossoms close at night time and do not open until the temperature rises again the next day. The period when the poppies are open and the wind is still is brief, so be ready to shoot a little after sunrise. A solution to this problem is to use perspective control (PC) lenses designed primarily for architectural photography. You can tilt the lens to change the

A camera angle that illuminates the subject from the back overcomes the problem that high contrast light creates for transparency films, most of which have a narrow exposure latitude. This patch of flowers caught my eye because of the purple blooms arranged in a diagonal flow—always a strong design element. Canon T90, 300 mm L Canon lens, Fujichrome Velvia, f/5.6 at 1/125 second.

plane of focus so it aligns more closely with the scene being photographed, thereby reducing the depth-of-field (and as a result the aperture) required to bring the elements of the picture into sharp focus. With these lenses you can attain full depth-of-field with shutter speeds up to 1/200 second with ISO 50 film.

In addition to shooting the poppies as principle elements of the greater landscape, you can work close-up to record details of the wildflower meadows. I like to do this using a long lens (400 to 500 mm) to isolate a single bloom or a small group of blooms within a matrix of out-of-focus flowers. The informal appearance of such compositions belies the careful deliberation required for achieving a compelling image. If shooting with such a long lens at maximum aperture, the limited depth-of-field reduces apparent contrast between shadows and highlights, and gives pleasing results even during midday.

Both these photographs illustrate the value of simple compositions incorporating strong color. Filters were used in each image to increase color saturation. The meadow (top) was photographed with a Cokin graduated pink filter and a graduated neutral density filter positioned over the sky. The oak tree (bottom) was shot with a Cokin graduated neutral density filter placed over the sky.

OTHER ATTRACTIONS

The grassy, rolling hills and scattered oak groves of this part of California offer good opportunities for scenic work. The numerous rocky coves between the nearby coastal towns of Malibu and Santa Barbara are excellent for recording classic seascapes-at-sunset shots. Look for beaches which have scattered rocks and islets near shore. These elements create wave patterns as the water flows around them, and can be used to frame the sun and indicate perspective.

Chipmunks & Squirrels

Banff National Park, Alberta • Summer

Chipmunks & Squirrels

Mount Rundle (right) is one of the many dramatic peaks in Banff National Park. Although most of the park is wilderness, many of its most photogenic features, including rich wildlife habitats, are easily reached by roads or hiking trails.

DRAWING NATURE photographers from all over the world, the Canadian Rockies offer alpine landscapes and wildlife unsurpassed elsewhere in North America. Ice-clad peaks, mantled with evergreen forests, rise majestically more than 3,000 meters (10,000 feet) above the Alberta prairies. The mountains are bedecked with sparkling glaciers, hanging valleys, turquoise lakes, wildflower meadows, waterfalls, and tumbling, snow-fed rivers. The region's excellent system of roads and trails makes it easy to reach many of these attractions.

Wildlife of all kinds, from porcupine, snowshoe hare, and least chipmunk to wapiti, bighorn sheep, and black bear, is abundant. Easily accessible from the town of Banff is a site atop Sulphur Mountain where you can photograph four species of chipmunks and squirrels in a few hours. These energetic rodents pose and perform for the camera on lichen-covered rocks and amid patches of flowering alpine vegetation.

The best time to photograph, unfortunately, is during the height of the crowded tourist season—July and August. The wildflowers, which can be incorporated into your pictures as important design elements, are usually at their best during this period.

Weather in the Canadian Rockies is unpredictable and changeable during summer. Generally, you can expect pleasant shooting conditions but be

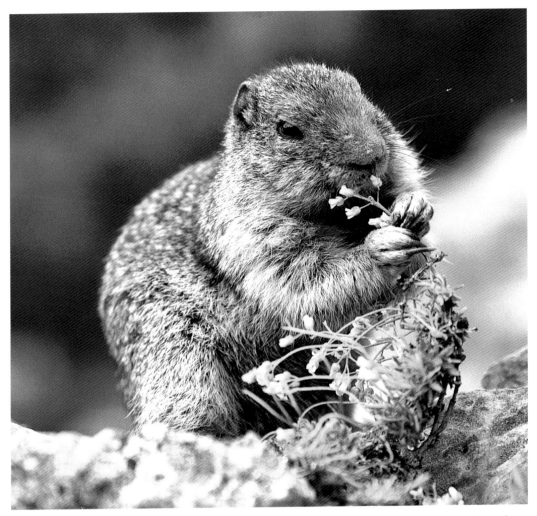

Left: Although herbs are a natural part of the diet of the Columbian ground-squirrel, this one is actually searching for peanut butter that I dabbed on the leaves to lure it to an attractive setting. Canon T90, 300 mm L Canon lens, 25 mm extension tube, Kodachrome 64, f/4 at 1/350 second. Below: Eyes are the most important visual cue when humans communicate with one another, and so a clear presentation of the eyes is desired even in photographs of wildlife. Canon T90, 500 mm L Canon lens, 25 mm extension tube, Fujichrome 50, f/4.5 at 1/250 second.

prepared for cool weather, rain, and even snow at higher elevations. (For Banff National Park information call ☎ 403 762 1550).

ACCESS AND ACCOMMODATION

Photographers not within driving distance of Banff should fly into Calgary, Alberta, a large modern city 90 minutes by car from the park boundary. Try to schedule a flight that allows for arrival in Calgary in time to pick up a rental car (two-wheel drive is adequate) and find accommodation in Banff the same day. Banff has an abundance of moderately priced to expensive motels and inns and many good restaurants. I don't make reservations in advance but try to arrive by mid-afternoon while there is still a good selection of

rooms. There are several full-service camp-grounds on the outskirts of Banff.

SHOOTING STRATEGIES

You can reach the top of Sulphur Mountain (2,300 meters [7,500 feet]) with all of your equipment via a gondola lift that runs continuously during daylight hours in summer. From the top of the lift, you need only hike a hundred meters to reach the heart of rodent country. The rambunctious creatures (yellow-pine chipmunks, golden-mantled and Columbian ground squirrels, and red squirrels) have just a couple of months to raise their young and store enough fat to last through the severe alpine winter. They are abundant here, together with bighorn sheep, due to hand-outs from people lunching in the picnic areas.

Set up in a private area away from the lunch crowd and within a few minutes you will attract a group of curious rodents. Select a site with rock outcrops and flowering alpine vegetation. The rocks make good platforms where you can shoot the rodents eye-to-eye without having to lay on the ground. The best way to bring your subjects within shooting range and have them stay put for a few seconds is to use peanut butter as bait. Dab it onto the rocks out of camera view near flowers or lichens in order to attract the rodents to a colorful

Above: During the summer breeding season, the blue grouse is frequently encountered near sub-alpine trails in the Canadian Rockies. Except when escorting newly hatched young, they are tame birds that can be cautiously approached for frame-filling portraits with a 500 mm lens. Right: There are many opportunities to photograph wapiti along Banff's roads and trails. Back-lighting outlines the velvet antlers of this bull. I closed down 1/2 stop from an average exposure reading to retain the deep color of the wapiti and the forest background. Canon F1, Fujichrome 50, 500 mm L Canon lens, f4.5 at 1/90 second.

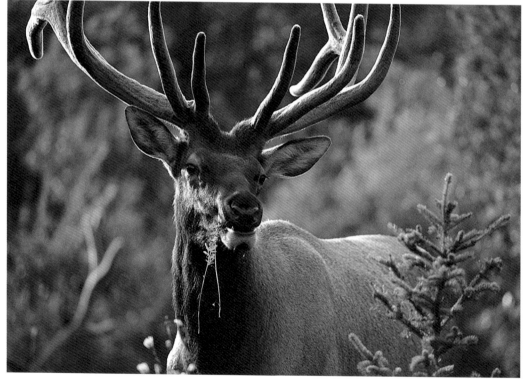

setting. If the animals have trouble finding the bait, you can make a trail of small, peanut butter smears leading from their general area of approach to the setting you have framed with your camera. The chipmunks and squirrels cannot carry off the peanut butter, so they will linger long enough to give you a chance to adjust framing and focusing and fire off a few pictures.

A 300 mm or longer lens will provide adequate working distance and magnification. Although a shorter lens would allow for frame-filling photographs, the narrow perspective of the longer telephoto lenses renders the shallow depth-of-field that creates the intimate feeling of good wildlife portraiture. For close-up focusing, take about 100 mm of lens extension (either extension tubes or extension bellows), or a +1 to +2 diopter screw-on supplementary lens. Although there is a lot of fill-light that bounces off the rocks, you can take a collapsible reflector to control subject contrast. In the mountains, I carry ISO 50 film for shooting wildlife and landscapes, resorting to a faster film when the sky becomes overcast.

OTHER ATTRACTIONS

Banff National Park is one in a string of four beautiful national parks that occupy this stretch of the Canadian Rockies. The others are Jasper, Kootenay, and Yoho. There also are several provincial parks of equal beauty. The region offers an inexhaustible source of shooting opportunities, and some nature photographers have fashioned successful careers working nowhere else.

Among the Banff area's many highlights are bighorn sheep. To photograph them, try driving up the winding road leading to the ski lifts on Mount Norquay. Watch the open meadows along the road for small herds of sheep grazing and sparring with one another. The road from Lake Minnewanka to Johnson Lake is also a prime area for sheep.

The road bordering Vermillion Lakes due west of town is an excellent place to record mountain reflections at sunrise and sunset when the atmosphere is calm. For roadside wildlife (elk, moose, deer, coyote, mountain sheep, and black bear), drive the Bow Valley Parkway (not Trans Canada Highway 1) from Banff townsite to Lake Louise. The icefield parkway between Lake Louise and Jasper offers dramatic alpine landscapes, one after another, complete with waterfalls, emerald lakes, and moody icefields.

It's nearly always advisable to position the camera at the subject's eye level, as seen in the photograph of the bighorn lamb (left) and the porcupine (above). This angle creates a feeling of intimacy between the viewer and the animal. In most situations, it also places the background well out of the depth-of-field zone, simplifying the setting and giving visual emphasis to the main subject.

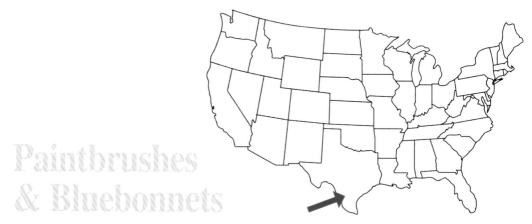

Paintbrushes & Bluebonnets

Edwards Plateau, Texas • Spring

The Edwards Plateau (Texas Hill Country) is laced with small highways and rural backroads. The shoulders of these routes are covered with lush vegetation due to the extra moisture they receive from highway run-off. Here you will find the most dense and colorful patches of wildflowers. Many roadsides have been seeded with native species by the state highway department.

THE EDWARDS PLATEAU in central Texas, popularly known as Texas Hill Country, bursts into color each spring as wildflowers of many varieties bloom. Red paintbrushes and bluebonnets (lupines), the best known and most eye-catching of these floral displays, team up to paint the landscape with saturated patches of blue and scarlet. There also are hundreds of other kinds of wildflowers (more than 5,000 species recorded in the state) that you will find in tempting masses: asters, daisies, sunflowers, phloxes, coneflowers, gaillardias, primroses, Indian blankets, wine cups, clovers, irises, verbenas, buttercups, and many others. Not only do natural conditions favor the growth of wildflowers, but the Texas Department of Highways, with 800,000 acres under its jurisdiction, sews much of its land in showy native species.

Generally, the floral extravaganza begins in March, peaks in mid-April, and tapers off by the end of May. The lower the elevation, the earlier it begins and ends. The richness and peak of the blooming season is difficult to predict and depends on numerous factors. Usually a spring preceded by a dry summer and harsh winter makes for a good show. To get current information, call the Texas Wildflower Hotline (☎ 512 832 4059).

Cold spells with below-freezing temperatures are unusual in this part of Texas in spring, and

This photograph of Indian blankets is the product of a double exposure. One exposure was made with the central blooms in sharp focus at a motion-stopping shutter speed of 1/250 second. The other was made at a shutter speed of one second, which caused the wind-jostled blooms to blur. Each exposure was made at one stop under the suggested meter reading so that when combined, an average exposure resulted. Canon EOS A2, 20 mm Canon lens, Fujichrome Velvia.

with some luck you will experience mild weather and pleasant shooting conditions, likely with a mix of cloud and sun.

ACCESS AND ACCOMMODATION

The town of Fredericksburg lies roughly in the center of the Edwards Plateau. From here the hill country spreads out in all directions for about 100 kilometers (60 miles). Both San Antonio and Austin are situated on the plateau's eastern border and are satisfactory fly-in destinations with plenty of accommodations and car rental agencies (two-wheel drive is satisfactory).

Fredericksburg and Kerrville are two small, peaceful towns with motels and bed-and-breakfast lodgings that make excellent headquarters. There are numerous mom-and-pop lodgings scattered through the area to service increasing numbers of tourists. You might prefer to stay on the move, taking up new quarters each day, depending on where the search for wildflowers leads you.

SHOOTING STRATEGIES

Wind is the greatest handicap to successful wildflower photography. Even light breezes make it impossible to attain sharp images due to the slow shutter speeds that are required when using close-up devices—extension

Right: This wind-tossed meadow of paintbrushes and Texas bluebonnets was created from the photo above on a desktop computer. Using blurred-motion wildflower photographs in my collection as reference, I used a variety of filters and retouching tools in Adobe Photoshop to create this new image. Right: This butterfly landed on a wildflower I was photographing—not an unusual occurrence when you consider that nectar is its main source of nutrition. Canon T90, 500 mm L Canon lens, Fujichrome Velvia, f/4.5 at 1/250 second.

long lens, set at maximum aperture and equipped with an extension tube for close focusing. This produces pleasing results, even at midday, thanks to the shallow depth-of-field and consequent blurring of shadows and shadow edges. Another way to shoot in sunny midday situations is to position the camera at ground-level so that you are shooting upward at the petals and leaves which consequently become back-lit. Avoid including bright areas of sky in the background. This technique works best with species whose petals are translucent (lupines, cone flowers, daisies, and others with light colored blooms). Such blossoms will be trans-illuminated, full of color, and pleasingly rim-lit. Effective exposure can vary from that indicated by central spot-metering to one stop under.

tubes or bellows, which not only reduce the amount of light reaching the film, but the depth-of-field, making small apertures necessary. Additionally, high magnification accentuates any movement by the subject. Calm atmosphere is most likely in the early morning. If it is windy, you can use it to your advantage by making blurred-motion images using slow shutter speeds to intentionally soften and streak picture elements. Fortunately, in this part of Texas, winds are light and sometimes non-existent, so you may frequently have good shooting conditions throughout the day.

You are likely to find attractive arrays of blooms anywhere in the region. Many of the state highway shoulders are seeded and have meadows with abundant flowers. You also will find many good patches on the quieter, more pleasant backroads, where passing vehicles are unusual events rather than a non-stop assault on the nervous system!

If ambient light is high in contrast due to a lack of clouds, I concentrate on working with a

So plentiful are the scenic wildflower byways in this part of Texas that you will come across photo opportunities just by wandering about and following your hunches. The blooming peak for each area varies from spring to spring and lasts only a week to ten days, so the routes suggested here may not be as good as others because of timing. From Fredericksburg, try the loop drive to Johnson City, then to Llano on Highway 71 and back to Fredericksburg. Along this route is LBJ State Park, a reliable wildflower site in mid-April.

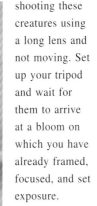

Most of the roadsides surrounding Austin and those east of San Antonio in Dewitt County can be productive. In Austin, visit the National Wildflower Research Center on Slaughter Lane off Loop 1, south of Highway 290. The center has about 40 beautiful acres seeded with various species as well as a butterfly garden. There also are a number of excellent wildflower routes around Burnet, about an hour's drive northwest of Austin. Try the loop drive south from Burnet on Highway 281 to Marble Falls, then northwest on winding Road 1431 toward Kingsland and the junction of Highway 29, which takes you east back to Burnet.

OTHER ATTRACTIONS

Where there are wildflowers, there are bees and butterflies. You will have the most success shooting these creatures using a long lens and not moving. Set up your tripod and wait for them to arrive at a bloom on which you have already framed, focused, and set exposure.

The rolling countryside is sprinkled with live oak groves, small villages, old churches, cemeteries, rock walls, and grazing livestock, all of which can add interesting elements to wildflower scenes. There are a number of national forest preserves north of Houston. One such preserve well worth visiting is Big Thicket, where you will encounter blooming dogwood, azalea, pitcher plant, and sundew in the spring.

I used three common design principles to identify these Mexican hat wildflowers as the photograph's center-of-interest: I set the focus and depth-of-field so the flowers became the most detailed (sharpest) elements in the picture; I placed them against a dark background and among less saturated blooms so they became the brightest and most colorful elements; and I adjusted the camera angle so they appeared in the middle of the frame—the most attractive region of a two-dimensional artwork.

Monarch Butterflies

Santuario El Rosario, Michoacan, Mexico • Winter

The Michoacan countryside is sprinkled with picturesque villages and family farms. Idyllic in appearance, the area, nevertheless, supports little wildlife and provides few views that do not exhibit the presence of humans. The potential for scenic wilderness photographs within the sanctuary is also limited.

EVERY AUTUMN, ABOUT 100 million monarch butterflies migrate 5,000 to 8,000 kilometers (3,000 to 5,000 miles) from the United States and Canada to the mountainous state of Michoacan in tropical Mexico. This over-wintering range is situated at an elevation of 3,000 meters (10,000 feet) among tall pine and fir forests. During the night, the butterflies cling in enormous masses to the higher limbs of the trees. With wings folded to show their dark undersides, the butterflies appear as large clumps of foliage. But as the sun rises and warms the atmosphere, wings begin to flutter, lighting up the forest canopy with orange splashes of light. As the temperature climbs, the blue sky overhead fills with butterflies on the wing. Soon they descend by

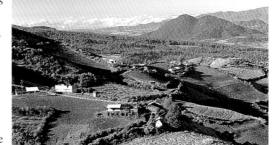

the hundreds and thousands to swirl about the forest floor.

The Santuario El Rosario is within easy driving distance of Mexico City. The butterfly season is at its best from November through March. At this time of year it can be cool in the mountains before the sun appears over the ridges. Occasionally it drops below freezing at night.

ACCESS AND ACCOMMODATION

You can fly into Mexico City and rent a car at the airport (four-wheel drive is advised). From Mexico City it is about 160 kilometers (100 miles) through the beautiful mountains of Eje Neovolcanico to the small, pleasant town of Angangueo. There are several comfortable inns

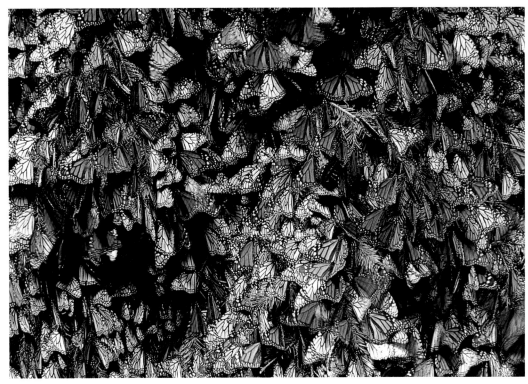

Above: A system of rough, steep trails winds through the butterfly sanctuary. You are permitted to venture off them for a better camera position. Left: The clumps of monarchs are usually found high in the trees, making a long lens necessary to obtain frame-filling compositions. Canon EOS A2, 400 mm L Canon lens, 2X teleconverter, Fujichrome Velvia, maximum aperture at 1/15 second.

here which derive much of their business from butterfly tourists. To find the sanctuary the first time, it is best to hire a guide in town; the staff at your hotel can arrange this. It's a rough journey up to the sanctuary in a two-wheel drive vehicle, especially after a rain. You may wish to hire a guide with transportation for your first visit to evaluate the conditions. If you are making the trip independently, don't be surprised if you are stopped by local Indians who collect a small toll for using the road. At the sanctuary, there are some refreshment stands, pit toilets, a small natural history display, and kiosks where you must pay for parking and for a guide to take you along the trails to the butterfly roosting spots, which change continually. The hike is a steep climb and lasts about 45 minutes one way. You can shoot as long as you wish.

Shooting Strategies

Films of ISO 50 to 100 best record the rich color and detail of the butterflies. Be sure to take an electric release for vibration-free, hands-off shooting. Avoid exposures in the 1/30 to 1/90 second range as these shutter speeds usually create the most in-camera vibration. If possible, lock up the mirror prior to shooting. You will need to take fast lenses of 500 mm and longer to make frame-filling pattern shots of the butterfly groups. Together with close-up accessories, a tripod, and all of your other field gear, this makes for a heavy load. For five dollars, the guide will shoulder

Right: To record the detail of this stem full of butterflies, I positioned the camera so the film plane was parallel with the line-up of monarchs. This was necessary because of the wind, which was jostling the subject, making a fast shutter speed and large aperture unavoidable. The limited depth-of-field that resulted had to be positioned carefully to include all of the insects. Canon EOS A2, 70-200 mm L Canon lens set at about 150 mm, 25 mm extension tube, Ektachrome EPP 100, f/2.8 at 1/60 second.

your heaviest bags, carrying them all the way up and back without breaking a sweat. If it is crowded, one guide usually takes a group of six to eight people. Ask for an extra guide (there are plenty), if necessary, for equipment toting.

Once you reach the groves where the butterflies are resting (there are three or four major sites), your main goal will be to find clumps of butterflies that are low enough to attain tight framing. The densest masses are unfortunately in the forest canopy about 20 meters (65 feet) from the ground. In the early morning, the butterflies are too cold to rouse themselves and there is little color to record. As the temperature rises, the monarchs open their wings and you can begin shooting. The best conditions occur on cloudy days when the ambient light is low in contrast. You should be on location ready to photograph by 10:30 am. If it is sunny, the butterflies will be swirling everywhere by midday.

OTHER ATTRACTIONS

This mountainous area is one of the most picturesque in Mexico, with small villages built into the hillsides and cultivated, patchwork fields decorating distant vistas.

Big Game

Brown Bears

Brooks Camp, Alaska • July to September

From Brooks Camp, you may venture unaccompanied to a variety of settings— open tundra, forest, river, still pools, and waterfalls— to photograph brown bears. The bears are unafraid of humans, providing numerous opportunites for close-up photography. Although these carnivores are not aggressive, you should not attempt to approach them—let them come to you. Be sure to give ample space to bears that are feeding and to mothers with cubs.

BROOKS CAMP IN KATMAI National Park is the most convenient location in the world to photograph fishing brown bears. North America's second largest terrestrial predators, the bears are attracted here by the approximately one million salmon that migrate up the Naknek system of lakes and rivers to their ancestral spawning beds. Brown bears of all ages are scattered throughout the region. At the two-meter (six-foot) high Brooks Falls, between Naknek Lake and Lake Brooks, up to forty bears may be seen fishing simultaneously, sometimes shoulder-to-shoulder! Here you may photograph brown bears standing at the top of the falls, peering intently into the rushing water with jaws ready to clamp onto a sock-eye or coho salmon as it

leaps from the water. There are nearly as many fishing styles as there are bears. Some individuals chase salmon through the shallows, while others snorkel about in deeper pools. A few jump onto their prey from large boulders. There are frequent opportunities to photograph mothers with cubs and bears quarreling with one another over the prime fishing sites.

Katmai National Park is a spectacular wilderness area of pristine lakes, rivers, marshes, and mountainous and volcanic landscapes. Aside from brown bears, there are moose, wolves, red foxes, minks, river otters, loons, grebes, and bald eagles—to cite the more readily observed wildlife.

The best time to visit Katmai is during the last

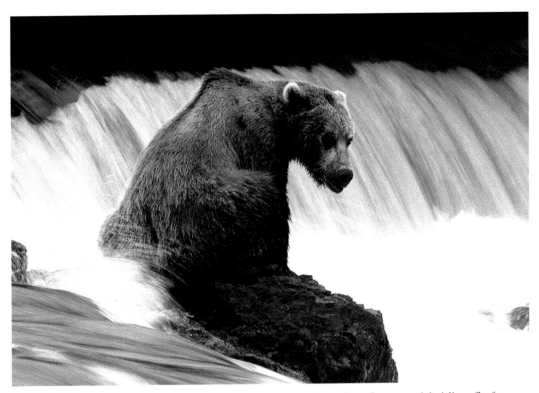

half of July, all of August, and the first half of September—the period when the most salmon are in the river system. It is usually cloudy and windy in Katmai so be sure to take warm clothing and raingear. Summer temperatures are usually in the mid-teens C (60's F) during the day, with occasional windgusts up to 80 kph (50 mph). Rubber boots or hip waders will be useful when traveling and shooting around the lakes, rivers, and marshes.

ACCESS AND ACCOMMODATION

Brooks Camp (about 20 minutes by foot from Brooks Falls) can be reached only by float plane (Katmai Air, ☎ 800-544-0551) from the town of King Salmon, 57 kilometers (35 miles) to the west. A number of commercial airlines fly from Anchorage to King Salmon (including Mark Air, Peninsula Airways, Alaska Airlines). At Brooks Camp there is a full-service lodge offering home-cooked meals and 16 modern rooms with baths. Room reservations should be arranged a year in advance by contacting the concessionaire, Katmailand Inc. (☎ 800 544 0551). There is also a primitive campground with tables, firepits, and pit-toilets near the lodge with space for 60 people (☎ 907 246 3305 for reservations). The maximum stay is seven nights. Bears sleep on the lake shore next to the campground and sometimes walk among the tents, especially at

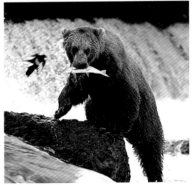

night. All food in the campsite must be stored on an elevated, bear-proof platform. Usually you will have no trouble reserving a site. Campers can eat at the lodge and there is a trading post with a limited selection of supplies and souvenirs. (For maps and more information, call Katmai National Park, ☎ 907-246-3305).

SHOOTING STRATEGIES

At Brooks Falls you must shoot from a viewing platform with room for about 25 people. You are not permitted to wander about anywhere in the vicinity of the falls and you must stay on the access trail at all times. The platform itself is too high for dramatic eye-to-eye portraits, but it generally provides a good vantage point from which to photograph the bears' activities. Fast lenses in the 300 to 800 mm range will be the most useful. You will be shooting in overcast light most of the time. On

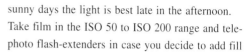

sunny days the light is best late in the afternoon. Take film in the ISO 50 to ISO 200 range and telephoto flash-extenders in case you decide to add fill light.

In the middle of the day, tour groups are flown in for a quick look at the bears. The platform becomes crowded, leaving no room to set up a tripod. A Bogen Superclamp can be attached to the railing to support your camera. You also may lash your tripod head and center column to one of the posts with a few yards of packing tape.

The bears usually catch a fish in mid-stream and then walk over to the shore to tear it apart and eat it. Sometimes this happens right below the photography platform, providing good opportunities for close-up shots. Mothers bring fish to their waiting cubs (up to four per litter) and sometimes take time to nurse them. The close-quarter feeding creates tension among the bears and there is frequent growling, aggressive posturing, and occasional brawling. Mothers are especially nervous and irritable because the males kill their cubs, given the opportunity.

There is another more spacious viewing platform located at the floating bridge near the lodge where smaller numbers of bears, especially mothers with cubs, may be seen, as well as a lot of fishing humans. The light is particularly good here in the early morning on sunny days,

There are other places where you may encounter bears away from the over-photographed waterfall setting. The lower part of the trail (near the lodge) crosses some pools where bears can be photographed

Right: I trained the lens on this bear when I saw it moving toward a dark background which I knew would create the impression that the subject was spot-lit. Canon T90, 500 mm L Canon lens, Fujichrome Velvia, f/4.5 at 1/30 second. Below: At nearby McNeil River Falls, another brown bear shooting location, there are good scenic opportunites right from the campsite. Canon T90, 80-200 mm L Canon lens set at about 135 mm, Cokin graduated neutral density filter, Fujichrome 50, f/8 at 1/15 second.

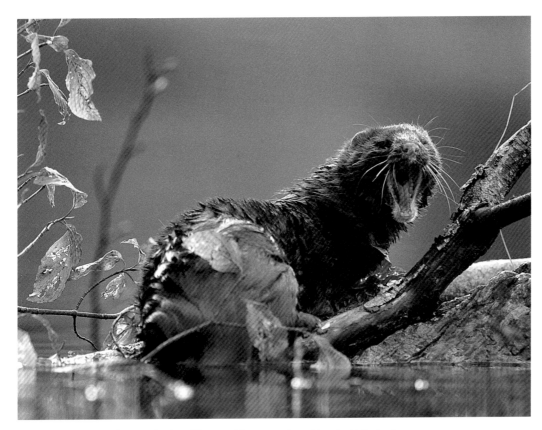

Other animals are attracted to the feast of salmon and salmon eggs along the Naknek River system, although they generally go unnoticed because of the scene-stealing bears. For back-lit subjects positioned against a background of average brilliance, such as this mink, I take a meter reading of the entire scene, and then reduce exposure by 1/2 stop to retain detail in the highlights. Canon T90, 500 mm L Canon lens, Fujichrome 100, f/4.5 at 1/125 second.

together with their reflections in the still water. The Naknek lakeshore near the campsite can also be productive, especially for bears taking a snooze. Generally, you should be ready to photograph bears anywhere. On my visit, I watched a male running about near the lodge with a dead cub in his mouth.

OTHER ATTRACTIONS

A dirt road runs 37 kilometers (23 miles) from Brooks Camp to the Valley of Ten Thousand Smokes, where you can overlook a volcanic landscape sculpted by glaciers and stream erosion. The concessionaires operate vans, accompanied by park rangers, which make daily excursions to the valley from Brooks Falls Lodge.

Ostensibly accessible only by lottery, you can usually make on-the-spot reservations (due to cancellations) in King Salmon to shoot at the nearby McNeil River State Game Sanctuary. Here the brown bear experience and setting is much the same as at Brooks Falls. However, you must visit these falls as part of a group of about 10 people accompanied by a ranger. At the mouth of the river, there is a ranger's cabin and camping area (no facilities) where you must stay. Brown bears are common in the tidal estuary in front of the campsite and the scenery is magnificent.

Elephants & Waterholes

Hwange National Park, Zimbabwe • All Year

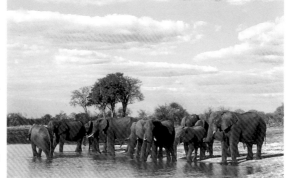

There are numerous waterholes at Hwange National Park and most of the larger ones are visited daily by herds of elephants. The open terrain and fair weather provide good lighting. Your first task will be to locate a photographic site which is amenable to shooting from a vehicle.

SOME OF THE LARGEST elephants in Africa can be found in herds of 100 or more in Zimbabwe's Hwange National Park. A bull elephant measures up to 2.9 meters (11.5 feet) at the shoulder—a monstrous presence, especially when it is standing an arm's length from your car. Hwange's huge elephant population is due in part to the wells (bore holes) dug at several locations in the reserve to provide water for wildlife. At many waterholes you will see large herds at certain times of the day. You also will have frequent opportunities to photograph giraffe, zebra, impala, gazelle, sable antelope, and greater kudu. There are plenty of lions in the park and smaller numbers of other carnivores, including African hunting dogs. Unfortunately, you must stay on the park roads, which means the only chance you will have to photograph these species is in the rare event that they make a kill near the road.

Hwange encompasses 9,000 square kilometers (3,200 square miles) of wilderness, varying from desert scrub on the fringes of the Kalahari Desert in the southern part of the park to granite hills interspersed by valleys of mopane woodland in the north. Although Hwange is Zimbabwe's top game park in terms of animal abundance and variety, as well as one of its most accessible, you will never feel crowded.

The best time to visit Hwange is during the dry season (September/October) when game is

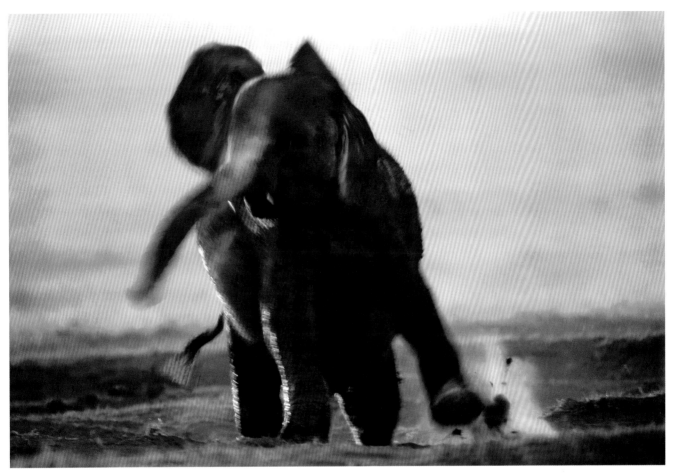

concentrated near the waterholes. However, other times of the year are likely to be just as productive due to on-going drought conditions. The weather is pleasant, with warm, sunny days and cool nights.

ACCESS AND ACCOMMODATION

Visitors from outside Africa fly into the capital city of Harare—a clean, safe, and modern base from which you can begin exploring Hwange and other of the country's natural attractions. There are many hotels in varying price ranges and numerous car rental firms. Two-wheel drive is sufficient, as you are not allowed to drive off the roads in any of the parks. Hwange is about 700 kilometers (420 miles) from Harare, and is reached by an excellent paved road with sparse traffic. If you wish to break up the journey, stop in Bulawayo—a pleasant, provincial town (Zimbabwe's second largest) with numerous hotels and restaurants. Not to be missed is an overnight stay at the authentically battered Gwaai River Hotel (☎ 263 18 355),

The long drought at Hwange has turned much of the landscape to dust and made the waterholes even more essential to wildlife. Elephant threat displays are common. Canon EOS A2, 100-300 mm L Canon lens set at 300 mm, Fujichrome Velvia, f/5.6 at 1/125 second.

located a short distance from the entrance to Hwange Park. It has been a favorite stopover for safari hunters for many years.

Within the park there are numerous, reasonably priced lodges and cottages, none of them luxurious but all comfortable enough. Most serve full meals. There are also campsites with pit toilets, firewood, drinking water, and sometimes showers. Although you can usually find a place to stay on-the-spot, the popularity of Hwange, especially during school holidays, makes reservations advisable. These can be made by mail (a deposit must be sent to hold the reservation) from outside Africa, or in Harare by contacting the National Parks Central Booking Office, 93B Jason Moyo Ave., P.O. Box 8151, Causeway, Harare, ☎ 263 4 706 077.

Main Camp, near the park entrance, is the

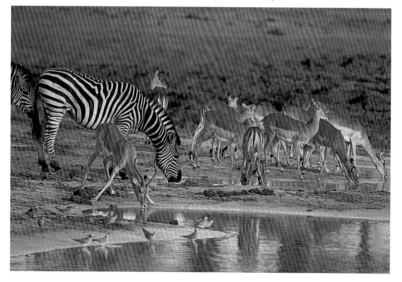

best place from which to conduct photography, with a number of excellent waterholes and pans within easy reach. During my visit to Hwange, the park was suffering a long drought, with trees and scrub devoid of foliage and savannah turned to dust.

SHOOTING STRATEGIES

Of concern to photographers is the fact that you may not leave the lodge or campsite compound until sunrise, and you must be back at the gate before sunset. This means a lot of fast driving in the morning to get to your intended shooting location while the sun is still low, and a similar rush to get back to the gate before it closes at sunset.

On your first day at Main Camp, make a general reconnaissance of the various circuits that lead to the waterholes and pans. It is wise to separate the locations that appeal to you into 'morning' and 'evening' categories, depending on the type of light desired. When you pull up to a waterhole, the park road disappears into a confusion of tracks, both vehicular and elephantine, so you have a good excuse to park some distance from where the road is intended to be to gain a better shooting angle. Unlike in the Serengeti, where you search actively for game, in Hwange you wait for the animals to come to you. You will have the most luck early and late in the day.

The elephants usually appear in a cloud of dust, thirsty and on the run, sometimes a hundred at a time. A large group spends an hour or so bathing and drinking. You should shoot from a tripod set up in the car. Lenses in the 200 to 500 mm range are necessary for full body shots.

To express the feeling of speed, I panned along with these sprinting impalas and used a slow shutter speed to blur their motion. Canon EOS A2, 500 mm L Canon lens, Fujichrome Velvia, f/13 at 1/30 second.

Other animals of all kinds, including birds, come to the waterhole before and after the elephants leave, so the wait is exciting.

You will find the *Tourist Map of Hwange National Park* (available at Main Camp or in bookstores in Harare) helpful in comparing notes with other visitors and finding your way around the park. Ask other tourists and the rangers about the most active waterholes. My favorites in the area of Main Camp are Kaoshe and Longone Pans.

OTHER ATTRACTIONS

Zimbabwe is a wild garden of flowering trees and picturesque landscapes which you may wish to explore at length. Two parks besides Hwange are well worth visiting. Matopos National Park,

just outside Bulawayo, has white rhinos (under guard) that a ranger will show you. (A tip will get you closer!) Mana Pools National Park on the Zambezi River, is nearly the equal of Hwange, with great herds of buffalo and elephant. There is a lovely campground (no lodge or restaurant) right on the river with toilets, showers, and firewood. You can rent a full set of camping gear in Harare at Rooney's (☎ 263 4 792 724). Mana Pools is the only park in Zimbabwe where you are free to walk about on your own, although the abundance of elephants and buffalos makes this hazardous.

Howler Monkeys

Bermudian Landing, Belize • All Year

The jungles where the howler monkeys are found are dense and grow on flat terrain, making it difficult to show three-dimensional perspective. A viewpoint elevated above the close understory is advantageous. This scene was taken from the veranda at the Jungle Drift Lodge. A graduated neutral density filter was used over the top half of the composition to retain the color detail of the sky.

THE ROAR OF THE BLACK howler monkey is one of the most unforgettable jungle experiences. These rather tame primates can be readily located and photographed in the jungles of the Community Baboon Sanctuary. Its headquarters are located at the tiny village of Bermudian Landing in north-central Belize.

The howlers ('baboons' to the local people) are about the size of a human toddler and live in troops of four to eight animals. These family units sleep and feed together, roaming over home territories of 10 to 15 acres. The howling is a territorial call produced from an enlarged bone in the animal's throat. You will hear their calls frequently at dawn and dusk, except during the rainy season when mid-day howling is common. The monkeys also howl in response to other loud, repetitive noises—rainstorms, car engines, or humans imitating their calls, for example.

The Community Baboon Sanctuary is a landmark conservation project. Established in 1985, it involves the private property of eight farming villages scattered along the Belize River. The residents have pledged to protect corridors of native vegetation along the river and the edges of their cultivated plots where the howlers forage. Local businesses benefit from the increase in ecotourism. Howler populations have expanded under the program to the extent that surplus troops have been transplanted to other nature reserves where howl-

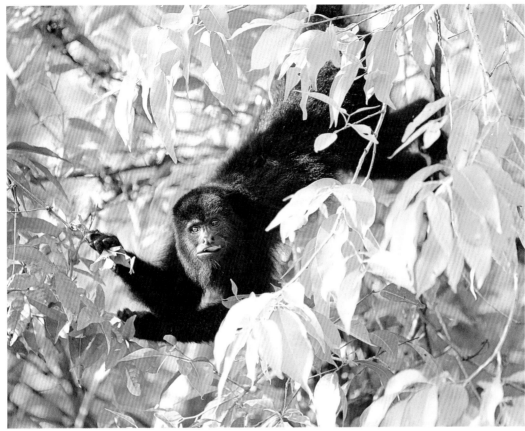

Although you usually will be forced to shoot the monkeys from below, a long lens reduces the apparent angle and gives the impression that you are shooting at the animal's level. This howler monkey was about 8 meters (25 feet) up and 30 meters (100 feet) distant. Canon EOS A2, 400 mm L Canon lens, 2X teleconverter, Ektachrome EPP 100, maximum aperture at 1/125 second

ers were once extirpated. The high density of monkeys guarantees visitors a sighting. If you strike out at dawn on one of the trails, you are likely to be standing beneath a troop of baboons a few minutes later.

More than three-quarters of Belize is forested and one-third is devoted to nature reserves. The Maya Mountains dominate the southern region and coastal plains, and plateaus occupy the north. There are many rivers, swamps, and freshwater lagoons. This mixture of landforms, coupled with varied rainfall, has created a rich mosaic of habitats and wildlife.

Belize is warm and humid. Tropical clothes, rain protection for camera equipment, and plenty of insect repellent will be essential items on your list of things to pack. The dry season runs from January through May. Although sunny skies will make your stay in Belize more pleasant, they are not well suited for photography. The dark color of the howlers records best in overcast light, and the monkeys themselves tend to vocalize more throughout the day when the weather is wet.

ACCESS AND ACCOMMODATION

Bermudian Landing is about 100 kilometers

Above: I tried to limit the distracting influence of the sky in this composition by careful adjustment of camera angle and tight framing. Canon EOS A2, 400 mm L Canon, Ektachrome EPP 100, f/2.8 at 1/500 second. Right: The Belizean jungles are home to hundreds of species of birds. This yellow-naped parrot was photographed at a bird feeder. Canon EOS A2, 400 mm L Canon lens, 1.4X teleconverter, Fujichrome Velvia, maximum aperture at 1/125 second.

(60 miles) west of Belize City, the capital of Belize and site of the country's international airport. Direct flights from the United States are offered on TACA, Sahsa, American, and Continental airlines. Europeans must travel to Belize via a gateway city in the U.S. The air terminal in Belize City is tiny. Right outside the front door are a half-dozen car rental agencies. Here you can rent a car inexpensively (two-wheel drive is adequate), pick up a complimentary map, and be on your way to the baboon sanctuary in a few minutes. It takes less than an hour to reach Bermudian Landing.

At the village, someone is likely to greet you as you drive up the town's single street. If not, stop in at the main bar—you can't miss it—and ask whether a guide is available with whom you can arrange trips to find the monkeys.

Several of the villagers offer substandard bed-and-breakfast accommodations for monkey watchers. It is better to stay at the reasonably priced Jungle Drift Lodge (☎ 501 1 49578) on the northern edge of the village. You can make arrangements to cook your own meals or to have them cooked for

you in the lodge's kitchen. (There is a restaurant next door that is best avoided).

SHOOTING STRATEGIES

With the help of a guide, you won't have any trouble finding howlers. But it is not easy to get good photographs, especially during fair weather. The dappled pattern of sun and shade in these broad-leaved forests, coupled with the monkeys' black color, results in contrast beyond the latitude of color slide film. The monkeys spend most of their time in the treetops, presenting a good view of their undersides and little else. The heat and humidity is oppressive, and there are hordes of mosquitoes.

It will require some persistence to catch your subjects in good light at camera level. The guide will help by hand-feeding cashew fruits to the monkeys, but this soon loses its effectiveness and the troop may wander away. You can stimulate the monkeys to howl by howling yourself.

Fast, long lenses in the 400 to 500 mm range will be most useful, although shorter lenses

At the Belize Zoo, you can photograph many native species, such as this ocelot, in natural surroundings free of bars or fences. For an extra fee, photographers may enter the enclosures with a zoo-keeper/trainer to make close-ups. Canon EOS A2, 400 mm L Canon lens, Fujichrome Velvia, f/2.8 at 1/350 second.

should be kept handy for close encounters, which are not unusual. Telephoto flash, or a silver-sided reflector held by an assistant, will help open up shadows and reduce contrast.

OTHER ATTRACTIONS

The Jungle Drift Lodge specializes in float trips down the Belize River, where you may encounter howler monkeys, many birds including toucans and parrots, and innumerable orchids, bromeliads, vines, and huge trees. Also in the vicinity is the Crooked Tree Wildlife Sanctuary, a wetland home to jabiru storks, wood storks, and many other water birds. To work here you need to use a floating blind or shoot from a small boat which can be readily hired, complete with a driver/guide. The Belize Zoo, near Belmopan west of Belize City, retains many of region's native birds and mammals in large compounds with natural vegetation. Photographers can pay an extra fee to work inside the enclosures in the company of one of the zoo-keepers.

Winter Wildlife

Yellowstone National Park
Mid-November to April

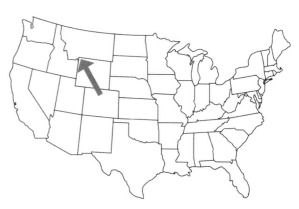

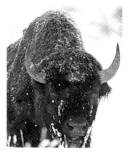

Bison are one of Yellowstone's most common and easily photographed animals. Although they seem as harmless and tame as cattle, they may charge unexpectedly at high speed. If you are interested in close-up views, a long lens is necessary for safe photography .

YELLOWSTONE NATIONAL PARK is known throughout the world for its magnificent scenery, spewing geysers, and wildlife. Overcrowding causes some photographers to stay away during the warmer months, but in winter the crowds have dispersed and traffic is non-existent (most of the roads are closed). Travel is done by snowmobiles, snowcoaches, snowshoes, or skis. The beauty of the quiet landscape and the abundance of wildlife drawn to the warmth of the thermal basins make this an outstanding destination for photographers.

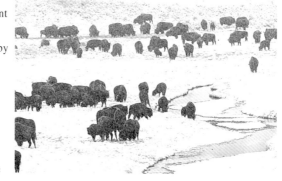

Yellowstone is a region of high plateaus and mountains in the northwest corner of Wyoming. Winter begins in earnest in mid-November and lasts until May. You are assured of photographing elk, bison, mule deer, moose, pronghorn antelope, bighorn sheep, coyote, and trumpeter swan. Mountain lion, lynx, wolf, river otter, mink, and weasel are also active—but it takes luck to see these species. Evergreen forests, prairies, snow-clad mountains, rivers, hotsprings, geysers, and waterfalls are added photographic attractions. Grand Teton National Park, acclaimed for its magnificent mountain scenery, lies near the southern boundary of Yellowstone.

Due to the high elevation, winter can be as harsh here as anywhere on the continent, so you should equip yourself with professional outdoor apparel. Take extra camera batteries and plastic bags to protect your equipment from moisture

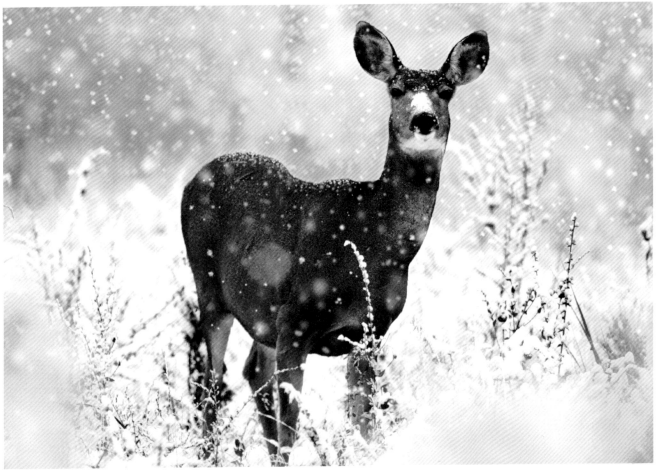

condensation once it is brought indoors. Be prepared for both snow and sunshine.

ACCESS AND ACCOMMODATION

General park information is available at ☎ 307 344 7381. The southern and northern park entrances are near the best photography locations and provide the most convenient routes of access into the park.

The nearest jetport to the north entrance is in Billings, Montana. Here you can rent a car (two-wheel drive is adequate) for the three-hour drive to Gardiner, located just outside the park entrance. In Gardiner (Chamber of Commerce ☎ 406 848 7971) there are restaurants and numerous motels, most with empty rooms during winter. Accommodations and food services are also available at the Mammoth Hotsprings Hotel (☎ 303 297 2757), a few miles inside the park.

The northern region has 90 kilometers (55

Falling snow adds magic to any portrait of winter wildlife. There were a few flakes in the original photograph of this mule deer. On a desktop computer, using digital imaging techniques in Adobe Photoshop, I multiplied these flakes to create a convincing flurry.

miles) of paved road between Mammoth and Cooke City that is ploughed all winter. This is the only area where you will be able to work from your car. Snowmobiles, equipped with insulated suits, helmets, goggles, and gloves, can be hired in Mammoth for traveling into the Yellowstone interior.

In the southern part of the park the roads are closed in winter, so travel is by snowcoach or snowmobile. Jackson, Wyoming (Chamber of Commerce ☎ 307 733-3316) is a tourist center serviced by various airlines with numerous motels, restaurants, and car rental agencies. A shuttle bus (☎ 307 733 4325) will pick you up at your motel or at the airport to take you to Flagg Ranch, the southern entrance to Yellowstone. Here there is single motel (The Flagg Ranch Resort ☎ 800 443 2311), a small restaurant, and snowmobile rental for venturing into the park.

From Flagg Ranch, you may proceed by scheduled snowcoach 62 kilometers (39 miles) to Old Faithful Village, where there is accommodation at Snow Lodge (reservations are necessary, ☎ 303 297 2757). This area boasts thermal activity (including Old Faithful) and abundant wildlife. Snowcoaches, carrying up to ten people, venture from Snow Lodge through the park on groomed trails, stopping frequently to allow photography.

SHOOTING STRATEGY

I prefer to shoot in the northern end of the park where you can travel independently, either by private car or snowmobile. Lower in elevation and warmer than other parts of Yellowstone, this area attracts a great deal of wildlife in winter. Pronghorn antelope and bighorn sheep, rarely seen in other parts of the park, are common along some stretches of the road.

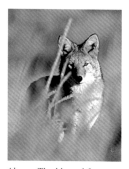

Above: The blurred foreground and background elements in this coyote portrait comprise the key elements of the composition. They frame the center of interest and accentuate its sharpness. Such effects are possible when using a telephoto lens at maximum aperture. Canon T90, 500 mm L Canon lens, Kodachrome 64, f/4.5 at 1/500 second. Right: Moose are found in and around willow thickets. They are most easily photographed in early November when Yellowstone's roads are not yet closed by heavy snow. When winter arrives in earnest, moose migrate into the forests and are difficult to find.

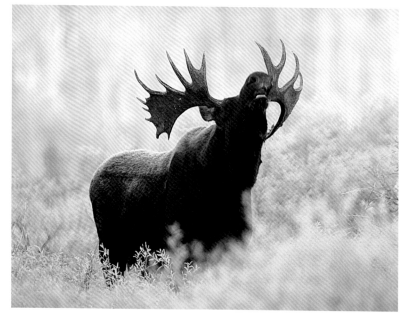

Animals are usually easy to approach and deep snows prevent them from moving too quickly. When hiking, follow the trails made by elk and buffalo. You may find wildlife anywhere, but it is concentrated near rivers and areas of thermal activity, often strung out along the streams flowing from geyser pools. In the thermal basins, rising mists create atmospheric effects which produce moody

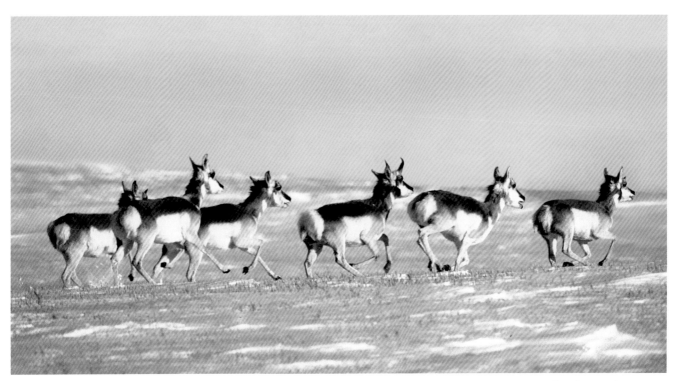

picture settings. Trumpeter swans are found in most of the ice-free rivers of the park and are unafraid if approached cautiously.

Telephoto lenses from 200 to 800 mm will be most useful. Due to the snow, there is ample light to use films in the ISO 50 range. Use a lens hood at all times to prevent snow from falling onto the lens surface.

Thermal mists, snow reflections, and warm, low light are the special elements that make the photography here exciting, especially during the periods of sunrise and sunset. When shooting a scene dominated by snow, remember to open up one to two stops from normal exposure settings. Alternatively, use the settings from metering an average subject under the same lighting conditions as the intended subject. Correct exposure in snowy settings is tricky, and bracketing up to one stop in half-stop increments is a wise precaution.

To extend battery life in cold temperatures, I use a detached battery pack carried inside my clothes next to my body. If your camera does not accept such an option, keep an extra battery inside your clothes to be switched in and out as necessary.

OTHER ATTRACTIONS

The scenery in Grand Teton National Park is more spectacular than in Yellowstone. There is also abundant wildlife and much of the park is accessible by road. The National Elk Refuge is situated on the northern outskirts of Jackson.

Pronghorn antelopes are sure to be found on the rolling prairies outside the north entrance to the park near the gravel road that runs along the west side of the Gardiner River. This photograph of a galloping herd was the best of about a dozen frames taken with a high speed motor drive—a boon to capturing fast action. Canon T90, 500 mm L Canon lens, Kodachrome 64, f/4.5 at 1/750 second.

Lions & Prey

Maasai Mara National Reserve, Kenya • All Year

The Maasai Mara Reserve provides an ideal setting for wildlife photography: open spaces with plenty of light, abundant game, and the opportunity to drive anywhere you wish in search of subjects. The only drawback is the equatorial location which reduces the amount of time available for low light shooting at dawn and dusk.

THE MAASAI MARA National Reserve in southwest Kenya lies in the northern reaches of the Serengeti Plains—the richest big game area in all Africa. With a landscape of grassland and scattered acacia trees, there are unobstructed views in all directions, allowing for easy game spotting. In August and September the great herds of wildebeest and zebra from Tanzania's southern Serengeti migrate into Kenya to graze on the fresh, long grasses of the Maasai Mara Reserve. This is the only time of year when you can photograph wildebeest crossing the Mara River en masse. Unfortunately, the grass is so high in some areas that it is difficult to locate and then get a clear shot of lions and smaller animals. At any

time of the year, you will find abundant wildebeest, zebra, impala, gazelle, topi, hartebeest, warthog, buffalo, giraffe, elephant, hippo, smaller herbivores, and the notorious carnivores—cheetah, leopard, hyena, and numerous prides of lion. During the dry season (December to March), game is easier to spot due to the shorter grasses. Moving herds kick up dust which dramatizes their passing and adds color to the atmosphere.

In Kenya (unlike Tanzania) you may easily conduct your own safari in a self-drive vehicle available from a variety of companies at reasonable cost. Good maps of Kenya and the Mara region are available in Nairobi in most bookstores. In the park you are not restricted to travel on es-

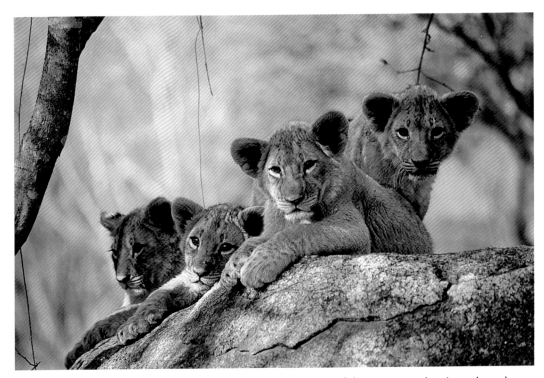

Left: It took patience to wait for these four lion cubs to arrange themselves for the camera and then the pose lasted only a few seconds. The foliage overhead softened the light of mid-afternoon. Canon EOS A2, 500 mm L Canon lens, Ektachrome EPP 100, f/4.5 at 1/250 second. Below: Lion kills are usually made during the night when vehicle travel in the park is not permitted Your best chance of recording this behavior occurs at sunrise when you may catch a pride finishing its dinner.

tablished roadways and may drive anywhere in search of photographic subjects.

Although Kenya lies on the equator, much of the country consists of mountains and high plateaus. In the Maasai Mara, it is hot enough during the day for shorts and cool enough at night for a jacket or sweater. Precautions against malaria and other diseases are necessary, so be sure to consult a doctor before leaving home.

ACCESS AND ACCOMMODATION

You may fly into Nairobi from several European and many African cities. For North American travelers the common route is through London, where there are regularly scheduled flights on British and Kenya airways. Once in Nairobi, arrange for the rental of a four-wheel drive vehicle

from one of the many agencies. A regular sedan will get you to the Mara, but it will not suffice for approaching game once you leave the main tracks.

It takes a full day to drive from Nairobi to the Mara, and you should get an early start, especially if you do not have reservations for the first night's stay. The roads vary from paved-with-potholes to bumpy dirt tracks that become slippery after a rain.

Most of the lodges are set up to handle tourist groups arriving by air charters or in mini-buses. However, independent travelers are welcome. You can make reservations for most of the camps in Nairobi, but you can usually

strike a better deal by negotiating a rate once you arrive. The lodges have different rates for residents and non-residents. However, the distinction is arbitrary. You may get the resident's rate if you tell them that your photographs will be used to educate people about the Maasai Mara Reserve and consequently bring them more clients. You likely will be asked for a business card.

Primitive camping is permitted at several locations. A few of the campsites may have water; be sure to purify it before drinking. Campers may use facilities at the lodges—bar, restaurant, toilets, and (with permission) the swimming pool.

I stay at the Mara River Camp (☎ 331191 or 229 009). It is reasonably priced and situated on the banks of the Mara River in one of the best game areas. It caters particularly to serious photographers, scheduling mealtimes to leave you free for shooting during the best light.

SHOOTING STRATEGIES

Park regulations prohibit leaving your vehicle when photographing. This is not a handicap because most animals run away at the sight of a human on foot anyway, and a car makes an effective blind. You will have to approach subjects carefully, especially herbivores which move away from approaching vehicles. Lions and cheetahs, on the other hand, may lie down in the shade of a car or jump up on the hood for a better view of the plains. A lens in the 500 mm range is the most useful, but other focal lengths should be kept close at hand.

Once you have hired a vehicle, you should set

Left: The well-defined stripes of the zebra make it an ideal subject for blurred motion imagery. The number of animals in a composition needn't be large, but the background should be colorful to contrast with the main subject. Canon EOS A2, 500 mm L Canon lens, Fujichrome Velvia, f/16 at 1/15 second. Below: You cannot photograph the Maasai people without permission, and for this you must pay. Most of them, however, do not understand the value of their service and demand unreasonable fees. For serious work, you need to enlist the help of an experienced local broker.

This buffalo, made nervous by the presence of my vehicle, was photographed from a tripod set up in the passenger seat. Canon EOS A2, 400 mm L Canon lens, 1.4X teleconverter, Fujichrome Velvia, maximum aperture at 1/180 second.

up a camera support, preferably one that allows you to shoot out of the passenger-side window which provides plenty of room to work with a long lens. One of the best methods is to put up your tripod over the passenger seat, planting the legs firmly on the floor of the vehicle and anchoring the tripod in place with elastic (bungee) cords hooked under the seat. By using a quick-release plate, you can unmount the camera easily when

moving between subjects and roll up the window if conditions are dusty.

On the equator the sun rises and sets quickly. and you will have good light only for about an hour at sunrise and sunset. Be sure to get an early start, arriving at the intended shooting location well before sunrise and an hour or more before sunset. During the middle of the day, I investigate new locations in preparation for the next shooting session.

Lions normally hunt after dark when the park is closed to vehicle travel, making it impossible to photograph most of their kills. Occasionally a kill is made late in the night and the lions will still be feeding at sunrise, enabling you to shoot the pride gathered around its prey in early morning light. Hyenas are similarly nocturnal but they feed in shifts: some adults remain at the den to keep an eye on the young while others eat at the kill. If you see a hyena loping in determined fashion across the savannah, it may be either heading to a kill or back to the den. In either case, it is worthwhile keeping it under surveillance.

For compelling portraits, keep the camera as low as possible by positioning your vehicle in ditches or natural depressions should they be available. I sometimes slip out of the car (using it to shield me from the subject), set up the tripod low to the ground, and then have my guide or companion drive off a few feet—just far enough to clear my view to the scene. The animals seldom notice the ruse. However, this is against park regulations unless you have special permission, and also could be dangerous.

It is best to hire a guide from one of the lodges to help you spot subjects during game drives. Guide fees are quite reasonable (about the cost of one roll of film per day). The guides know where to find the most exciting wildlife activities (lion kills, cheetahs with cubs, wildebeest crossing the river, etc.). If you hire a park ranger for a guide, he may sanction activity (such as leaving your vehicle) that will make shooting easier.

OTHER ATTRACTIONS

In the Maasai Mara Reserve there are opportunities to photograph hippos at numerous pools along the river. Your guide will be happy to show them to you. The most accessible ones are in the northwest corner of the park. You can approach the pools on foot and set up your tripod at the water's edge for dramatic shots. But keep in mind that more people in Africa are killed by hippos than any other animal!

The Maasai people are plentiful in the area and enjoy being photographed, provided you pay them. Some villages (manyattas) encourage visitors and have an interpreter/business manager available to provide information and collect fees. Even though they do not speak english, it isn't difficult to strike a deal with the Maasai on your own, should you encounter interesting individuals during your travels. Given the opportunity, they may steal small items that attract them. So keep unattended windows of your vehicle rolled up.

The surest way to attain compelling images of Serengeti wildlife is to concentrate on capturing dramatic lighting effects rather than particular subjects or special behavior. Varied lighting angles are possible late and early in the day when you may adjust camera position to achieve backlighting, evidenced in the cheetah portrait (left), sidelighting, as shown in the group of impalas (above), or front-lighting.

Polar Bears

Churchill, Manitoba
Mid-October to Mid-November

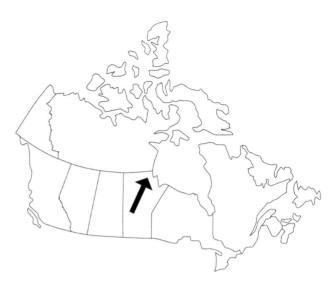

The polar bear habitat at Churchill is primarily open tundra and ice-covered beach. At this northern latitude, the sun remains near the horizon throughout the day. Combined with the reflective properties of the snow, this provides ideal uninterrupted lighting conditions.

NOWHERE IS IT EASIER to photograph polar bears than near Churchill, Manitoba. Bears gather here on the barren beaches of Hudson Bay during October and November to wait for ice to form on the bay. The ice makes a bridge which allows the bears to venture out to sea to hunt for seals, their chief prey. The small town of Churchill is situated in the taiga, a transition zone between treeless arctic tundra and boreal forest, and offers a variety of northern landscape and seascape settings for photography. About 90 kilometers (55 miles) south of Churchill is a major denning area for polar bears.

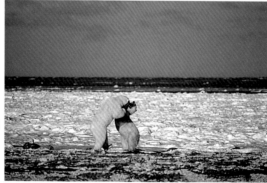

A male polar bear is the largest terrestrial carnivore, reaching nearly 3 meters (10 feet) in length and weighing up to 800 kilograms (1700 pounds). The females average about half this size and bear from one to four young.

Polar bears are one of the most dangerous subjects for wildlife photographers. Young males are especially aggressive and investigate any photographer shooting on the open tundra or along the beach. It is not safe to wander on foot in the vicinity of the beaches or other areas where bears congregate, particularly when visibility is restricted. (People are attacked even in downtown Churchill.) Bears are unpredictable and can move exceptionally fast. Work with a partner, remain alert, and stay close to a vehicle in case a quick escape is necessary.

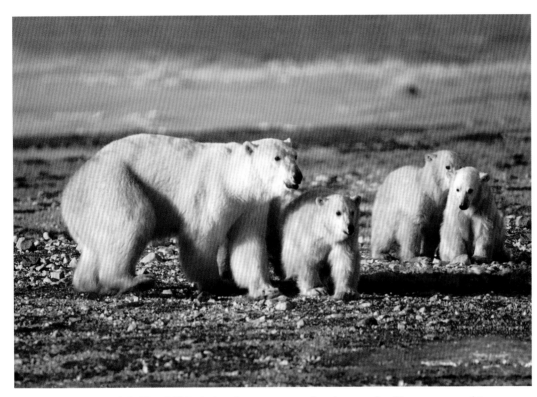

Left: Mothers with cubs are common subjects but patience is needed to capture a group when it is photogenically arranged. Below: Young male polar bears typically loaf along the shore of Hudson Bay, spending much of their time wrestling as they wait for the icepack to form. This photograph was taken from a pick-up truck parked nearby. Canon T90, 500 mm L Canon lens, Fujichrome 50, f/4.5 at 1/500 second.

The best time to visit Churchill is during the last half of October and the first half of November. It can be bitterly cold and windy in Churchill at this time of year, and heavy-duty, arctic expedition apparel is a must.

ACCESS AND ACCOMMODATION

You can reach Churchill from Winnipeg, Manitoba on Canadian Airlines (☎ 800 426 7000) or by train on Via Rail (☎ 800 561 9181), also from Winnipeg. There is no road access. Churchill has several motels and a few restaurants. Rooms are scarce during polar bear season so make reservations in advance through the Tourist Information Bureau (☎ 204-675-2022). You can walk anywhere in town in a few minutes, but a vehicle is necessary for photography. There are several tour companies which take groups to see the bears on 'tundra buggies' and school buses. But the large size and high vantage point of these vehicles make them far from ideal for attaining dramatic images. You may wish to sign up for such a tour and once you know your way around, rent a four-wheel drive vehicle from Tamarack Rentals (☎ 204 675-2006) for independent shooting.

SHOOTING STRATEGIES

Although getting close to the bears is not a problem, a lens in the 500 mm range is

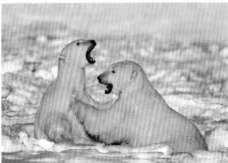

Above: The shooting plat-forms of the tundra buggies (which take out groups of photographers) are ideal for making scenic images of the flat landscape around Churchill but they are too high for attaining intimate portraits. Right: Arctic foxes scavenge the kills made by polar bears. At Churchill they also feed on the waste-water released by tundra buggies and camping vehicles parked along the beach.

beneficial due to the compressed perspective it renders. It will also be useful for subjects which are unapproachable due to difficult terrain. Bears may come up to your vehicle, lean against it, and peer through the window at you—a disconcerting experience! The sun stays low in the sky in the north at this time of year, providing good light throughout the day. Reflections from ice and snow illuminate shadows effectively. Sunrise and sunset can infuse snowscapes with rich color. A high contrast film, such as Fujichrome Velvia, in the ISO 50 to 100 range is ideal. Remember to open up one stop over the meter reading when shooting bears in snowy settings.

Concentrate on finding attractive subjects (mothers with cubs, young males wrestling, etc.)

and maneuvering for dramatic light and attractive backgrounds. You can look for subjects along the side roads around Churchill, as well as the tundra buggy routes near the beach.

OTHER ATTRACTIONS

Dramatic boulder-strewn landscapes and sea-scapes can be found on the outskirts of Churchill. Arctic foxes are common and tame. They follow the bears to scavenge from their kills.

Birds

White Pelicans

Bolivar Flats, Texas • Fall through Spring

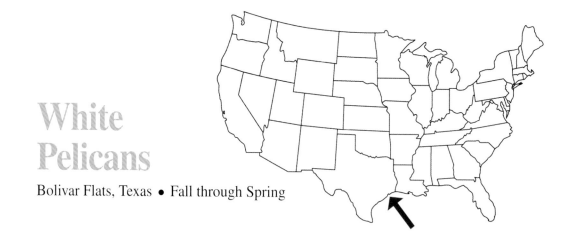

At Bolivar Flats, you will find white and brown pelicans and shorebirds massed together among the sedges and on the sandbars. During the winter, the sky is often overcast but, surprisingly, it makes a good backdrop for photography.

FEW BIRDS FLY WITH the ease of the white pelican. Viewed at close range from a blind, the enormous spread of its nearly three-meter (10-foot) wingspan is breathtaking. Not only is the white pelican graceful in flight, but it is decorated with beautiful, snowy plumage and a long, stout bill slung with a naked pouch for netting fish. The white pelican is gregarious and can usually be photographed in large flocks.

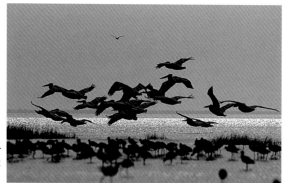

Bolivar Flats lies at the tip of the Bolivar Peninsula, a narrow, low-lying finger of land separating Galveston Bay from the Gulf of Mexico. The marshes and tidal flats of the peninsula make it one of the best areas on the north Texas coast to find shorebirds—avocets, black-necked stilts, marbled godwits, American oystercatchers, various sandpipers and plovers, as well as reddish egrets, roseate spoonbills, brown and white pelicans, gulls, and terns.

At any time of the year, there are plenty of subjects for the nature photographer. But winter is the best season, when the numbers of resident birds are swollen by over-wintering species. Spring and fall migration periods are also very productive and full of surprises as thousands of birds move along the coast.

During winter the seas are rough and gray, and provide a suitable neutral background for the abundant birdlife when it takes to the air. The weather tends to be overcast, windy, and cool

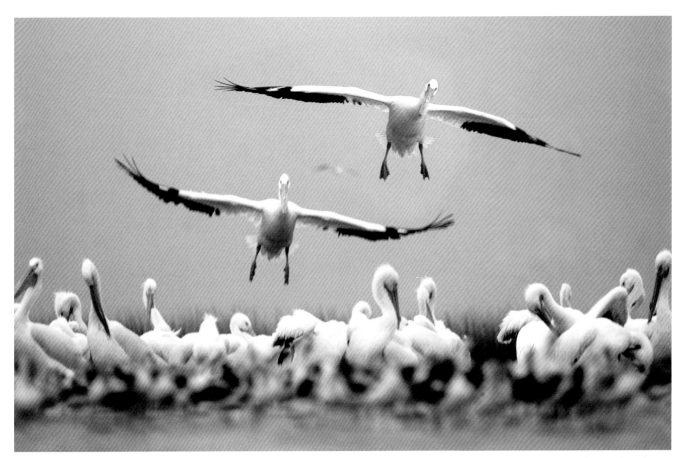

with frequent showers and fog. Sweaters, wind-breakers, and raingear are necessary.

ACCESS AND ACCOMMODATION

From Houston, Texas, it's about an hour by car (two-wheel drive is sufficient) to Galveston. Here you can catch the free car ferry to the Bolivar Peninsula. The ferry runs back and forth continuously and the crossing takes about 15 minutes. Bolivar Flats is only a few minutes drive from the ferry terminal. It's convenient to stay in Galveston where there are abundant lodgings and restaurants, rather than on the peninsula which has but a few rundown motels and restaurants.

SHOOTING STRATEGIES

On your first ferry crossing, be ready to shoot the flocks of gulls (mostly laughing gulls) which hover overhead, keeping pace with the boat and providing an excellent opportunity to record these handsome birds in flight. Blurred action shots work particularly well (especially if the sky is blue) by shooting at a speed of 1/30 to 1/60

I was photographing this preening flock from a blind when I noticed the two air-borne pelicans approaching. I knew they would land among the other pelicans on which I was already focused, so all that remained was to trip the shutter as they set down. Canon T90, 500 mm L Canon lens, Kodachrome 64, f/4.5 at 1/250 second.

second. You will have plenty of time to shoot a roll or two of film before the ferry arrives at the dock.

When you get off the ferry, drive about 1.5 kilometers (one mile) on State Highway 87, then turn right onto one of the streets that leads to the beach. As you near the gulf, you will notice various ponds and stretches of marsh. These are excellent spots for water bird photography from a stationary or floating blind. When you reach the shore, you should see a concrete jetty off in the distance to your right and thousands of shorebirds, terns, and gulls and scores of white and brown pelicans sleeping on the sandbars, parading along the beach, swimming just offshore, or floating in the strong breezes overhead.

You can drive along these hard-packed, sandy beaches with little fear of getting stuck, but avoid the dark blue patches of clay near the water's edge. You can shoot some birds, especially those perched on shrubs or sand dunes, right from the car, using it as a blind. The pelicans and other birds loafing or feeding on the tidal flats are best recorded from a low tripod with a lens in the 500 mm, or longer, range. You usually can approach smaller shore birds for tight group shots or even frame-filling portraits of individuals. The pelicans are also relaxed—much more so than ones I have photographed on inland marshes. Frame-filling group shots of roosting pelicans are possible if you approach slowly and stay low. At low tide the pelicans fish in shallow water 20 to 30 meters (65 to 100 feet) from shore, employing the co-operative techniques for which they are famous. For close-up portraits, you need to use either a stationary blind set up near an habitual roosting spot, or a floating blind that allows you to change your position depending on the activity of the birds.

Tides determine where you will find the shorebirds. At low tide they spread out to feed along the beaches and sandbars. High tide forces them inland to the shelter of the marshes and dune grass where they usually convene in large, dense flocks to rest and preen. Before setting up a stationary blind, it is best to check the tide tables in the local newspaper.

Films in the ISO 50 to 100 range are adequate, even if it is cloudy, due to the high reflective properties of the beach.

OTHER ATTRACTIONS

Explore both sides of the peninsula by taking the side roads that branch off from the main highway. At Rollover Pass, the narrowest part of

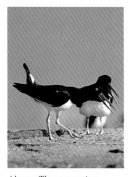

Above: These courting American oystercatchers were photographed from a mobile floating blind near their nest on a sand dune bordering the beach at Galveston. Canon T90, 500 mm L Canon lens, 1.4X teleconverter, Kodachrome 64, maximum aperture at 1/180 second. Right: I crept up on this sleepy roseate spoonbill in a mobile floating blind just as the sun dropped below the horizon. Canon T90, 500 mm L Canon lens, Fujichrome Velvia, f/4.5 at 1/30 second.

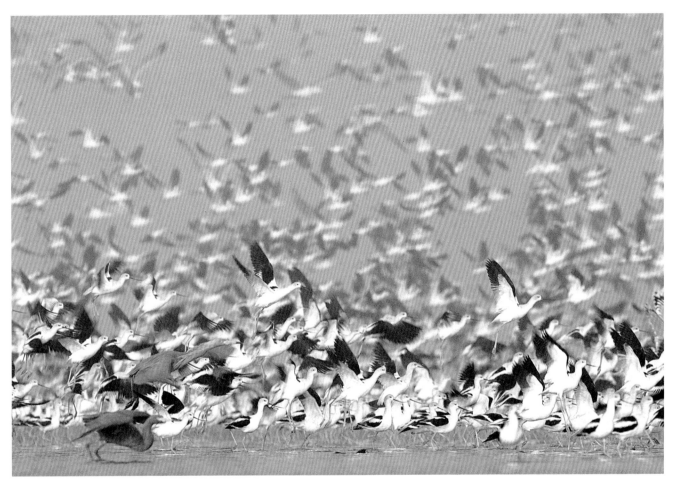

the peninsula, there are several small islands off-shore which support nesting colonies of roseate spoonbills, herons, egrets, skimmers, gulls, and terns in the springtime. Anahuac National Wildlife Refuge lies on the inland side of Galveston Bay at the base of the Bolivar Peninsula. It can be reached by traveling north on State Highway 87 then inland on State Highway 24. Unfortunately, access to attractive areas for photography is pro-hibited, but large over-wintering numbers of geese may produce some satisfying flight and flock shots. High Island, a small hump of land that draws songbirds migrating across the Gulf of Mexico to its sheltering patches of woodland, is about 48 kilometers (30 miles) north of Bolivar Flats on Highway 87. You will have the best luck here following a stormy day during April's peak migration season. Long lenses (500 to 800 mm) equipped for close-focusing are needed.

Shorebirds, such as this mass of avocets in winter plumage, attract numerous raptors which periodically swoop over the flocks set-ting them to flight. Canon T90, 500 mm L Canon lens, Kodachrome 64, f/4.5 at 1/250 second.

Trumpeter Swans

Elk Lake, Montana • June to mid-July

Elk Lake not only provides opportunity to photograph waterfowl, such as cinnamon teal (above) and trumpeter swans, but its pristine Rocky Mountain wilderness setting has much to offer the scenic photographer.

ONCE SLAUGHTERED FOR its meat and feathers, the trumpeter swan is one of the largest and heaviest birds in North America—with a wingspan of 2.4 meters (8 feet) and weighing up to 14 kilograms (30 pounds). It was feared extinct until 68 birds were discovered nesting in the marshes of the picturesque Centennial Valley of southwestern Montana. Red Rock Lakes National Wildlife Refuge (☎ 409 2763 536), adjacent to Elk Lake, was established to protect the species' breeding habitat. Today the population is more than 14,000 worldwide. At Red Rock Lakes, strict regulations prevent photographers from approaching the swans. However, trumpeter swans are common outside the refuge on nearby Elk Lake, and they can be photographed at close range from floating and stationary blinds in a peaceful and beautiful setting.

Elk Lake is set among gentle hills against a backdrop of snow-capped Rocky Mountain peaks. It is fed by blue-ribbon trout streams and ringed by marsh.

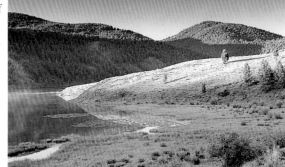

The lake provides breeding habitat for many birds: common loon, red-necked, pied-billed, and eared grebes, mallard, ruddy duck, ring-necked duck, Barrow's golden-eye, green-winged teal, and many others. The plentiful supply of fish supports families of minks and river otters and attracts great blue herons, black-crowned night herons, and white pelicans. Greater sandhill cranes nest in the wet meadows bordering the lake, and eagles and ospreys raise their young in the tall conifers that

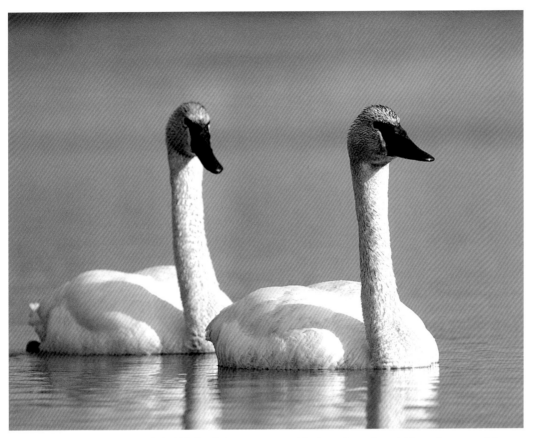

Close-up views of the swans at Elk Lake can only be recorded from a blind which may be set up at several locations where they come regularly to feed. The swans are curious and usually approach to investigate. Canon EOS A2, 400 mm L Canon lens, 2X teleconverter, Ektachrome EPP 100, maximim aperture at 1/350 second.

clothe the north-facing slopes of the hills bordering the lake. All manner of passerines nest in the aspen groves and grasslands. Moose, elk, and mule deer regularly come to the lake to drink or feed in the surrounding meadows. Pronghorn antelope are common on the open prairie south of the lake.

The Red Rock and Elk Lakes region is an unspoiled mountain/prairie ecosystem with an abundance of wildlife subjects and landscapes for photography. Except for fishermen, you're likely to have the entire area to yourself. June and July are the best times to photograph birds engaged in breeding activity and plentiful wildflowers in bloom. The weather at this time of year is variable, so be prepared for heavy rain and possibly snow.

ACCESS AND ACCOMMODATION

Commercial airports, two to three hours by car from Elk Lake, are found in Bozeman and Butte, Montana and in Idaho Falls, Idaho. You may fly into the West Yellowstone jetport from June through September. From West Yellowstone, it's an hour's drive southwest to Elk Lake via U.S. Highway 20. Rental cars are available from all of the airports (four-wheel drive is recommended). Turn off the highway at the sign to Red Rock Lakes NWR and continue toward

the refuge. As you reach the refuge boundary, you will see signed roads to Elk Lake and Elk Lake Camp. After periods of heavy rain, the road into Elk Lake turns to mud and is passable only with a four-wheel drive vehicle.

At Elk Lake there are two small, pleasant, primitive campgrounds (pit toilets only) and a comfortable, rustic fishing lodge called Elk Lake Camp (☎ 406 276 3282). Campers may eat and drink at the lodge, which has a bar, restaurant, and several cabins. It is only a short walk from here to the campground. Both the lodge and the campgrounds are on the lakeshore. Rental boats and motors are available at the lodge. Campers should do their food shopping in West Yellowstone before setting out.

SHOOTING STRATEGIES

The animals here are used to seeing anglers in boats but are shy of people on foot. To draw within shooting range of most birds, a blind is necessary. You can set up a stationary blind at a nest or use a floating blind, such as camouflaged float tube, to photograph trumpeter swans and other waterfowl engaged in courtship and feeding activities in the shallows. Whatever method you use, be careful that your activities do not create stress that may interrupt the birds' normal breeding and feeding activities. Detailed information on how to photograph birds safely at the nest can be found

in my book *Wild Bird Photography: National Audubon Society Guide* (see the appendix). You also may find it valuable to seek advice from an ornithologist. With such knowledge you will have a much better chance of obtaining satisfactory photographs.

The swans on Elk Lake are mated pairs that have not yet reached breeding age. These birds are territorial and pairs squabble with one another, both on the water and in the air. They are habitual creatures and you will be wise to observe their behavior for a day or so before deciding where to position your blind. The hills surrounding Elk Lake offer excellent vantage points from which you can take distant views of the swans swimming gracefully across a smooth expanse of water colored by a fiery sunset or brooding in the rising mists of early morning.

There is a rough, four-wheel drive track that runs along the shore of Elk Lake to another smaller lake, appropriately called Hidden Lake. On this route you will pass through aspen groves where several species of woodpeckers nest in cavities. Some of these sites are close to the track and can be photographed from your vehicle provided you remain hidden from view by draping camouflage netting over the car windows. Porcupines are common in the aspens. This road also passes through prairie habitat where you will find badger and ground squirrel burrows and a

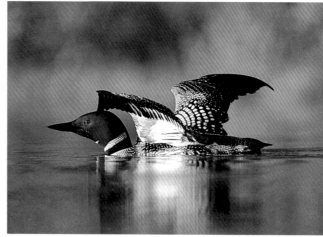

Mobile floating blinds, like the one above, are ideal for shooting all kinds of water birds and mammals. Being able to change position without frightening the subject affords control of camera angle, magnification, and background. A fisherman's float-tube, equipped with a camouflaged top to hide the photographer, is an easy way to get started in this type of photography.

The river otter (left) and the common loon (far left) are common species on Elk Lake, feeding regularly on the lake's abundant trout. Both were photographed from a floating blind made of a slab of styrofoam sandwiched between two sheets of plywood. When low to the water, the camera frames a background that is usually removed from the depth-of-field zone. This softens distracting details, simplifying and strengthening the composition.

profusion of lupines, shooting stars, paintbrushes, mallows, various composites, and other wildflower species during the spring and summer.

OTHER ATTRACTIONS

The wetlands on the Red Rocks Lake National Wildlife Refuge are prime moose habitat. Found along roadsides near patches of willow, the moose can be approached cautiously on foot. Pronghorn antelope roam the grassy flatlands of the refuge but they are wary and must be photographed from a vehicle. You frequently will see elk, especially in the evening, drinking at the lakes. Unfortunately, they are wary of humans due to hunting pressure.

Elk Lake is a few hours by car from Yellowstone and Grand Teton National Parks, two excellent big game destinations at this time of year.

Ospreys & Gray Whales

Guerrero Negro, Baja, Mexico • Late Winter / Spring

GUERRERO NEGRO, A lackluster coastal town of 10,000 inhabitants located halfway down the Baja Peninsula, is the well known staging area for whale watching trips into *Laguna Ojo de Liebre* (Scammon's Lagoon). The lagoon is a shallow body of water which serves as the calving area for more than 1,000 gray whales each winter. Not so well known is the fact that ospreys occupy dozens of nest sites on the outskirts of Guerrero Negro. The nests are built on the tops of short telephone poles, just four to five meters high, allowing for photography of the osprey's breeding activity from ground level.

Ospreys are nearly eagle-sized raptors (wingspan to 2 meters [6.5 feet]) that feed exclusively on fish.

The terrain in the vicinity of Guerrero Negro ranges from these multi-hued soda flats to sand dunes to saltwater marsh. Canon EOS A2, 15 mm Canon fish-eye lens, Ektachrome EPP 100, f/8 at 1/350 second.

They carry their prey head foremost, gripped between the vise-like talons of both feet. They are especially photogenic when hovering above the nest and when feeding the young, which number from two to four.

In addition to ospreys and gray whales, Guerrero Negro offers interesting scenic opportunities, including a lunar landscape of salt pans to the west, sand dunes to the east, and coastal marsh to the north. Further afield, the Baja Peninsula itself presents stark desert vistas of colorful rocks and jagged peaks framed by blue seas and skies.

The best time to photograph the ospreys is during April, when they are feeding their young on the

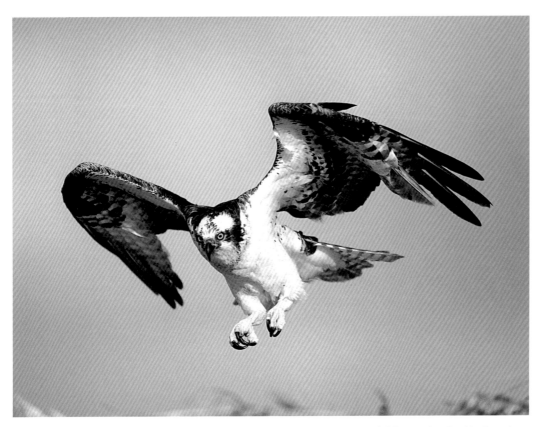

The osprey nests are located on the outskirts of Guerrero Negro along regularly traveled roads in an area of dikes and channels near the sea. You can drive up to most of the nests and shoot from inside or the top of your vehicle. Although the ospreys will carry on their nesting activities despite your presence, you should shoot with a lens of at least 500 mm and limit photography sessions at any one nest to one hour every other day. Left: Canon EOS A2, 400 mm Canon L lens, 2X teleconverter, Fujichrome 100, maximum aperture at 1/500 second.

nest. If you visit here in March, you will be able to photograph both the gray whales before they begin their northern migration and ospreys while they are incubating. Although the ospreys will not be feeding their young, you will be able to capture them flying to and from the nest and to record nest-building and courtship behavior. The number of whales in *Laguna Ojo de Liebre* reaches its maximum in February. However, successful photography of the whales is dependent on having calm, clear weather rather than numerous subjects.

Due to oceanic influences, the climate in Guerrero Negro is much the same year round. In winter daily high temperatures range from 15° to 18°C (59° to 65°F). Rainfall is rare, but fog blankets the area regularly in the morning, dissipating by mid-day. Strong winds blow steadily from the ocean. Although rarely extreme, the weather is generally cool and unpleasant.

ACCESS AND ACCOMMODATION

A car is necessary to photograph the ospreys, though not the whales. It is a long drive in your own vehicle from the United States or Canada (about 700 kilometers [430 miles] from the San Diego area). You can also fly into Ensenada, Mexico where rental cars are available but expensive. American multi-national companies usually have lower rates than the

local companies. From Ensenada, it is about a day's drive (600 kilometers [370 miles]) through featureless desert to Guerrero Negro on well-maintained, paved roads.

There are numerous inexpensive motels and restaurants in Guerrero Negro. An excellent (and cheap) place to eat is at the popular Don Ramon's Birreria located at the side of the main road as you enter town. Along the shore of Laguna Ojo de Liebre (less than forty-five minutes by car from Guerrero Negro) there is open, primitive camping with no facilities. Here you can watch the whales and the sunset as you fall asleep.

SHOOTING STRATEGIES

The waters at Laguna Ojo de Liebre are usually rough, making compelling whale photographs difficult to attain. You will not have any trouble finding or getting close to the whales but they show little of themselves above the water. Schedule your shooting session for late afternoon on a sunny day when you can maneuver for a camera angle which affords dramatic side or backlighting. With luck, you will be able to shoot the whales with the setting sun as background.

To find the osprey nests, proceed down the main street of Guerrero Negro (away from the peninsular highway). Turn right as soon as you pass the bank (named *Banamex*) and proceed toward the sea. As you near the coast, you will begin to see osprey nests on low, wire-

less telephone poles along the dikes and lagoons. For the best photography, look for a low nest which affords a simple background. For ospreys to reach their nests easily, they must land into the wind, which blows steadily from a westerly direction all day long. Ideally the birds should be facing the light, which means flight shots at the nest are best in the late afternoon. In the morning, if the sky is clear, the ospreys' eyes are in shadow when they land.

You can raise the camera position advantageously to nearly nest level by setting up a tripod on top of the vehicle (a motor home is perfect). You also can elevate yourself with a step ladder and attach stilts to the legs of your tripod. (PVC plumbing tubing works well for this.)

Your arrival at the nest will scare off the osprey (usually the female) momentarily, but it will return in a few minutes and you can begin shooting. Try recording both head-on and side views of the osprey as it lands. Although the bird will remain on the nest while you are working, your presence is disturbing nevertheless. The male, who will be perched nearby or out fishing, will not usually bring food to his mate when humans are in the vicinity. You should limit shooting sessions to about an hour per nest every other day.

Dramatic whale photographs seldom feature the gray whale, primarily because this species does not have an interesting form like the orca, with its great dorsal fin, or acrobatic swimming habits like the humpback, with its reliable exhibit of tail flukes when sounding. Further complicating the photography at Laguna Ojo de Liebre is

the wind—the water is often too rough to achieve satisfactory contrast between the whale and the waves. The lagoon is usually not calm enough, even for whale watching tours, until afternoon. The gray whale's most reliable aquatic show is spy hopping, which you should see frequently. The lagoon has a number of 'friendlies' that readily approach the tour boats, especially if there are children on board. Beside the lagoon, there is a kiosk where you register for the whalewatching tours conducted by local mariners in small open boats. A reasonable fee is collected for the tour which lasts about two hours. (You may not venture into the lagoon independently.) The best seat for photography is at the front of the boat where the view is mostly unobstructed.

OTHER ATTRACTIONS

To reach the sand dunes, follow the main highway out of Guerrero Negro toward Ensenada. After a few minutes you will see a turn-off to the left that leads to the airport. Take this road and continue past the small airport terminals until you reach the sand dunes about a kilometer (half-mile) further. They are best photographed at sunrise and sunset.

The multi-hued alkali flats are found alongside the road that leads to the new salt loading docks on the outskirts of Guerrero Negro. (There are many osprey nests on this route.) The surest way to get there is by asking directions from someone in town.

Grebes

Jicarilla Lakes, New Mexico
Spring through Fall

Stinking Lake, located in an isolated area of the Jicarilla Apache reservation, has the most abundant birdlife of the Jicarilla Lakes. Most of its shoreline is covered with cattails, bulrushes, and sedges—prime nesting habitat for many waterfowl species. Only a few feet deep over much of its area, the lake may dry up completely in times of drought.

IN ADDITION TO THE abundance of wildlife on the Jicarilla Apache Reservation in northwestern New Mexico, photographers will benefit from the absence of restrictions that confront them when shooting in national and state wildlife refuges or parks. Except for a few low key cattle ranches and oil wells, this area is undisturbed by man.

The reservation takes in more than 800,000 acres of mountains and hills covered with sagebrush spattered grasslands and mixed coniferous forests. The gems of this region are the lakes, all of which are within easy driving distance of Dulce, New Mexico, where the Jicarilla Apache tribal headquarters is located.

There are seven lakes (Dulce, La Jara, Mundo, Stone, Enbom, Stinking, and Hayden) in the area

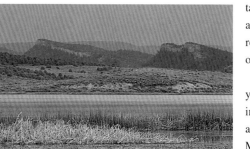

which you should explore for photographic possibilities. The most bird life is found at Stinking Lake, the largest natural lake in the state, and adjacent Hayden Lake which together encompass more than 1,300 acres of marsh. Ringed by extensive stands of cattails and bulrushes, they are located beside gravel roads in an isolated region of the reservation.

On these two lakes you can photograph nesting western, pied-billed, and eared grebes during May, June, and July (depending on the species). The dramatic ballet courtship of the western grebes begins in May. Eared grebe colonies of several hundred birds (up to 2,000 pairs in wet years) are established in July. Pied-billed grebes nest through the entire spring and early summer. There are numerous

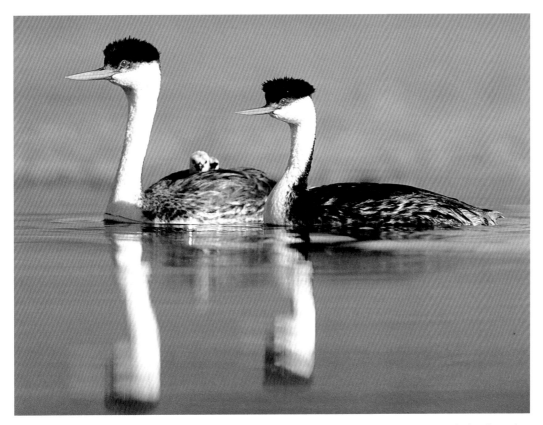

Left: Western grebes ferry their young about the marsh, occasionally offering snippets of vegetation over their shoulder to the tiny waiting beaks. All close-up photography at Jicarilla Lakes must be done from a blind. Canon EOS A2E, 500 mm L Canon lens, Fuji-chrome Velvia, f/4.5 at 1/350 second. Below: Black-crowned night herons feed on giant salamanders (mud puppies) which are abundant among the aquatic plants and algae during the summer.

other breeding birds, including a dozen species of ducks, white-faced ibis, black-crowned night heron, American coot, Virginia and sora rails, snipe, killdeer, yellow-headed and red-winged blackbirds, and common yellowthroat. During colder seasons, you will find common loon, bald eagle, osprey, white pelican, and common merganser attracted to the shallow waters. The upland areas provide breeding habitat for golden eagle, American kestrel, northern flicker, Lewis woodpecker, black-billed magpie, yellow warbler, mountain bluebird, house wren, and lazuli bunting to mention only a few species.

The weather changes rapidly in this mountainous terrain. Rain and snow are common during the spring and fall. Generally, the summer is warm and sunny during the day with light winds. Evenings are cool.

ACCESS AND ACCOMMODATION

The closest jetport is located in Durango, Colorado, 145 kilometers (90 miles) northwest of Dulce. In Durango you can rent a car from a variety of agencies. A two-wheel drive vehicle is usually sufficient, although some stretches of road on the reservation become impassable after heavy rains. At

Above: Eared grebes build floating nests in shallow water in colonies which may number up to one hundred pairs or more. The colonies are started seemingly without warning and completed in as little as a few hours. When the nest is built, the grebe begins laying eggs immediately. Canon T90, 500 mm L Canon lens, Kodachrome 64, f/4.5 at 1/500 second. Right: Blue-winged teal. Canon T90, 500 mm L Canon lens, Kodachrome 64, f/4.5 at 1/250 second.

the Jicarilla Game and Fish Office in Dulce (☎ 505 759 3442), camping permits, maps, and information are available. There are campsites with tables and pit toilets at four of the lakes. If you do not wish to camp, there is a Best Western Motel in Dulce. A reasonably priced, country lodge with a good cafe called the Stone House (☎ 505 588 7274) is conveniently located 3 kilometers (2 miles) west of Heron Lake on State Road 95. The lodge is about a 15-minute drive from Stinking Lake.

SHOOTING STRATEGIES

All close-up bird photography here must be done from a blind, either stationary or mobile. When you first arrive, it is necessary to spend a day or more observing bird activity in order to locate nest sites and determine which of these are suitable for photography. The road separating Stinking and Hayden Lakes is elevated, so you can observe most of the activity from above with binoculars.

For most species, only those nests which have young more than ten days old can withstand the stress that a photographer may cause, even if he is careful and uses a blind. It is generally futile trying to photograph the activity at a nest with eggs or unfeathered young. At this stage of development, the young likely will die due to predation, parental abandonment, or exposure to the elements should you attempt to set up a blind nearby. To make sure that my activity is not harming the birds, I prefer not to photograph at the nest at all. Instead I work quietly in the vicinity in a mobile blind, photographing the parents as they bring food to the nest, court one another, and forage.

Unlike most birds that breed here, grebes may be safely photographed at the nest while they are still incubating, provided the eggs are stained brown—an indication that the nest has been established for some time. Young grebes leave the nest soon after hatching, riding about the marsh on their parents' backs. The use of a floating, mobile blind is the best way of recording this behavior. Pied-billed grebes return to the nest frequently to brood their young.

OTHER AT-TRACTIONS

The prairies and parklands on the Jicarilla Reservation are home to numerous elk which you will see in the early morning and evening as they emerge

from the forested hillsides to graze. Unfortunately, these animals are regularly hunted and are difficult to approach for close-ups. However, they can be incorporated as interesting features in photographs of the landscape.

An abandoned homestead located beside the road about midway between Stinking Lake and Stone House Lodge, is a good location for photographing songbirds attracted to the meadows, fruit trees, and dilapidated barns and outbuildings.

Northwestern New Mexico and southwestern Colorado offer scenic landscapes at the southern terminus of the Rocky Mountain Range. Much of the area is wilderness, offering opportunities for photography at any time of year. The most famous natural landmark is Shiprock, a colossal slab of sandstone that projects out of the desert near the town of Shiprock, New Mexico, about 170 kilometers (106 miles) west of Dulce on State Highway 64.

During spring and fall migration, you will find loons fishing or resting on the larger lakes of the reservation. Although their movements are unpredictable, they are easy to approach in a boat and sometimes may even be photographed from shore without benefit of a blind.

Frigatebirds & Boobies

Isla Isabel, Nayarit, Mexico • Winter

The harbor at Isla Isabel is a great locale for scenic photography at either sunrise or sunset. If calm, the broad tidal pools provide reflections of the sky. Canon EOS A2, 20 mm Canon lens, Fujichrome Velvia, f/11 at 1/4 second.

MEXICO'S TINY ISLA Isabel (about three square kilometers [one square mile]) is a crowded nesting site for seabirds—principally magnificent frigatebirds, blue-footed and brown boobies, Heerman's gulls, and white-tailed tropic birds. Brown pelicans roost in abundance on the island's rocky shoals. The colonies are unprotected and the birds are used to humans due to the commercial fishing camp huddled in one of the island's sheltered bays.

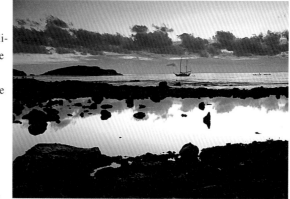

Most people visit Isla Isabel by chartering a boat from the coastal town of San Blas, 70 kilometers (43 miles) to the east on the Mexican mainland. San Blas, a favorite haunt of North American birdwatchers, is surrounded by marshes, mangrove swamps, coastal lagoons, and diverse tropical forests. These habitats host birds ranging from the bare-throated tiger heron to the cinnamon hummingbird. The town boasts more than 300 species during its annual Christmas bird count. The warm waters in the vicinity of San Blas and Isla Isabel are frequented by humpback whales, some of them very friendly. There are numerous broad, sandy beaches along this section of the coast. Popular with Mexicans on vacation, they offer good opportunities for scenic pictures.

The weather during the winter is lovely, with lots of sunshine, tropical temperatures, and little wind. Small boat excursions into the open Pacific

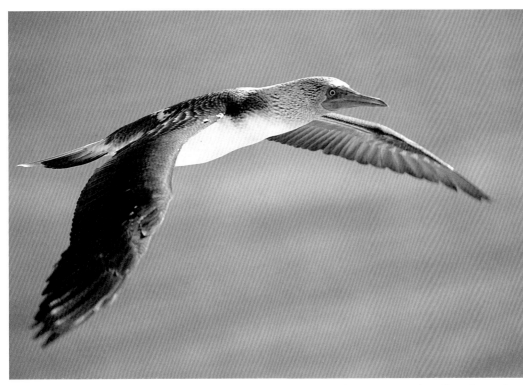

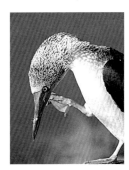

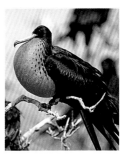

It is easy to record all manner of bird behavior in the rookeries at Isla Isabel. Blue-footed boobies (top) preen, frigatebirds (bottom) conduct courtship displays. With so many birds venturing to and from their nests, opportunities for flight shots are common. This blue-footed booby (left) was photographed near its cliff top rookery as it circled for a landing.

are chilly and sometimes wet, especially the long trip to Isla Isabel.

ACCESS AND ACCOMMODATION

Photographers living in the southwestern United States might consider driving to San Blas. It is a long but pleasant journey, especially if you follow the coastal route. There is an international airport in Puerto Vallarta, which is 160 kilometers (100 miles) south of San Blas. More than a dozen airlines service Puerto Vallarta and there are numerous car rental facilities here. A car will be valuable for exploring the rich birding habitats surrounding San Blas.

In San Blas there are many inexpensive hotels, a bank where you can change money, pharmacies, and plenty of restaurants and small outdoor cafes. Most facilities are situated near the town plaza, where there is a friendly gathering of residents and tourists each evening. The best lodging is at the Hotel Canela (☎ 328 50112).

Near the plaza about half-way down the town's main street is a tourist information center (☎ 328 50409) where you can make arrangements to be taken to Isla Isabel by a local boat driver/guide. Ask for Armando Santiago, who speaks perfect English and is experienced in leading nature tours to Isla Isabel and finding humpback whales.

The trip to Isla Isabel takes about three hours and begins in the morning to take advantage of prevailing winds. Dress warmly and be prepared

 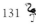

The humpback whales in the waters around Isla Isabel are fond of approaching small boats. You should have two cameras at hand—one equipped with a wide-angle zoom lens for those occasions when the whale surfaces right beside the boat, and the other equipped with a telephoto zoom lens for shooting the whales when they blow, emitting a cloud of spray, or dive, showing their large tail flukes.

for a rough ride in an open boat. There are no facilities (not even fresh water) on Isla Isabel. Firewood can be picked up along the beach. Most visitors stay overnight on the big, covered porch of an abandoned, partially built research station which is about a five minute walk from the fish camp (where you will land). You can pitch a tent anywhere you like. There are some nice sites in the sand along the beach. You must pack out whatever you pack in. While Isla Isabel is a beautiful tropical island in the middle of the blue Pacific, the abundance of junk and litter found in some areas provokes questions about the aesthetic sense of those who came before.

SHOOTING STRATEGIES

All of the birds can be approached in the open

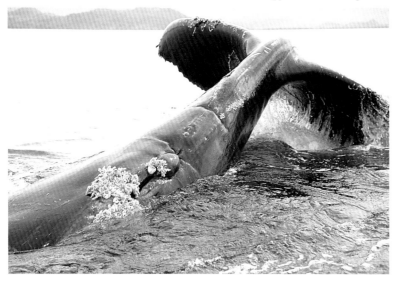

without need of a blind. The frigatebirds are especially tame and build their nests right beside the research station in groves of scrubby trees that have lost their foliage because of bird droppings. There are always birds flying about and quibbling over the nests. The best strategy is to position your camera and tripod to frame an attractive subject in good light against a simple background. By watching the activity in the rookery for a while, you can determine which territories are the most contentious and therefore likely to provide the most opportunities for bird interactions and flight shots. A 200-400 mm zoom lens is ideal for making quick adjustments to magnification—for switching from static portraits to flight shots to catching a nest-top fracas, all of which may occur within a few seconds. The frigatebirds frequently hover above their nests making it easy to capture them in sharp focus manually or automatically.

On the hilltop behind the research station is the blue-footed booby colony. These birds are easily frightened if you approach too closely, so you will need a lens of 500 mm or greater. If you visit the island in winter, the boobies will be engaged in some stage of reproduction, so be very careful not to upset them. You should be able to record their distinctive posturing which is part of courtship.

Brown boobies and Heerman's gulls nest and loaf on the oceanside rock shelf between the fish camp and the research station. This is also a good

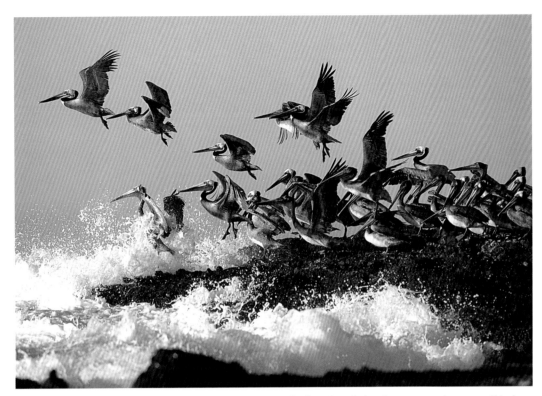

The rock shelves of Isla Isabel are roosting sites for brown pelicans and nesting areas for brown boobies and gulls. All can be approached cautiously in the open. Left: I used a full roll of film trying to catch a bunch of pelicans taking off while a wave crashed at their feet. Canon EOS A2, 400 mm L Canon lens, Fujichrome Velvia, f/2.8 at 1/1000 second.

place to photograph flocks of brown pelicans as they rest and preen. The pelicans fly off with little provocation, so stay low, avoid quick movements, and take ample time maneuvering for a shot. The rock shelf faces north, making it an excellent location for both sunrise and sunset seascape photography. At low tide there are still pools on the rock shelf which create good reflections of the sky's color.

OTHER ATTRACTIONS

There are numerous humpback whales along this stretch of the Pacific during the winter—and very few whalewatchers. The tourist bureau in San Blas will help you arrange a boat and guide for finding the whales. Leave as early as possible in the morning, when the waters are most likely to be calm which makes the whales easier to spot. See the sections (Orcas, Humpback Whales) in this book for tips on photographing whales. The whales are curious and may lie beside and under the boat, touching it gently with their flukes, and staring up at the human occupants. The whales are also acrobatic and breach frequently, often numerous times in succession.

The environs of San Blas boast great numbers and numerous species of birds—some of them are tropical residents, some are migrants from North America. There are numerous marshes where a floating blind can be put to good use.

Lesser Flamingos

Lake Nakuru, Kenya • All Year

Bird and mammal life is most common at the north end of Lake Nakuru (shown right). Here fresh water from the Njoro River trickles into the lake providing drinking water for wildlife. Due to low water levels, you can drive to the lake's edge, making photography from a vehicle possible.

CALLED 'THE GREATEST' bird spectacle in the world' by eminent ornithologist Roger Tory Peterson, Lake Nakuru, a shallow soda lake in East Africa's Great Rift Valley, lives up to its reputation. The lake is protected inside Nakuru National Park (200 square kilometers [75 square miles]). At one time, it was home to more than a million lesser flamingos. The numbers fluctuate periodically as the lake level changes, with many birds moving off to other soda lakes in the rift valley. Unfortunately, talapia were introduced into the lake and became the flamingos' direct competitors for brine shrimp. This may have caused what seems to be a permanent decline in the flamingo population. On the bright side, the talapia became a food source for white pelicans.

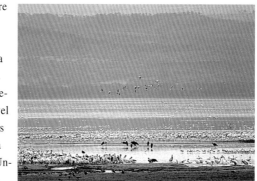

Even when flamingos are at a low ebb, the density of birds and variety of species (nearly 400) in the park is staggering. Along the water's edge you will see, in addition to flocks of flamingos numbering in the many thousands, a great variety of water birds—greater flamingos, marabou and yellow-billed storks, African fish eagles, ibises, ducks, geese, plovers, sandpipers, and gulls to mention only a few.

In addition to bird life, the lake shore is frequented by Defassa waterbuck, Bohor reedbuck, warthog, spotted hyena, silver-backed jackal, African buffalo, and hippopotamus. The park has been designated as a sanctuary for white rhinos. Rothschild's giraffes were successfully introduced in 1977.

Away from the lake, the landscape is a mix of

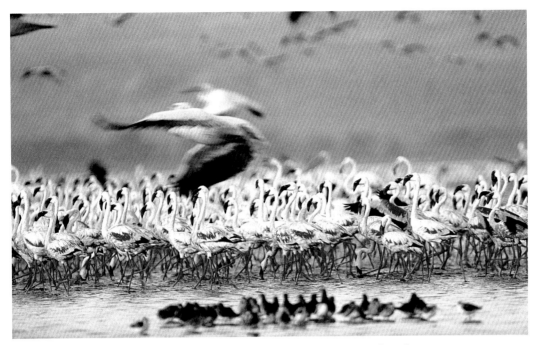

Left: To portray the abundance of bird life at Lake Nakuru, I focused on these parading flamingos, framed the scene to include the shorebirds in the foreground, and timed the exposure to capture the white pelican flying above. Canon T90, 500 mm L Canon lens, Fujichrome 50, f/4.5 at 1/125 second. Below: The yellow-billed stork is on of the hundreds of species you will see at Lake Nakuru.

rocky hillsides, grassland, and yellow-barked acacia woodlands. The sloped, eastern perimeter of the lake is covered with bizarre euphorbia forests. These habitats are home to many species of big game including zebra, gazelle, impala, eland, leopard (rare), cheetah (rare), as well as many smaller creatures such as olive baboon, various monkeys, small cats, porcupine, and mongoose.

Photography is excellent at any time of year. The weather is generally hot and sunny during the day and cool in the evenings.

ACCESS AND ACCOMMODATION

Lake Nakuru National Park lies due south of the town of Nakuru, Kenya's fourth largest urban center. It is a pleasant town that services the surrounding farmlands. Nakuru is 85 kilometers (52 miles) from Nairobi, the major gateway to East Africa for visitors from abroad. In Nairobi, there

are numerous agencies where you can rent a vehicle. Two-wheel drive is sufficient for shooting in the park.

There are two lodges within the park, Lake Nakuru Lodge and Sarova Lion Hill Lodge, which offer first-class accommodation. Reservations can be made from Nairobi but they are usually not necessary except on holiday weekends. You can also camp at the popular Njoro Campsite, not far from the main gate, which has pit toilets and potable water. The advantage of staying inside the park is that you can begin shooting before sunrise, a time of beautiful lighting effects on the lake. The park gate does not open until

This quarrel over a flamingo carcass between an African fish eagle and a marabou stork was recorded from a blind at Lake Bogoria. A low camera angle appropriately positioned the predators in front of a flock of flamingos.

seven a.m. If you do not wish to shoot at first light, staying in the town of Nakuru is an enjoyable way of organizing your safari.

Nakuru has several satisfactory economical hotels and restaurants, and is only a short distance from the park entrance. The most pleasant accommodation is the Hotel Kunste, located on the south edge of town on the main highway to Nairobi. Petty thievery is common in Nakuru so keep your vehicle locked and under surveillance at all times.

SHOOTING STRATEGIES

Unlike most of the parks in east Africa, you don't have to remain in your vehicle at Nakuru. You can walk down to the lakeshore, as close as you wish to the flamingos and other birds. Mother Nature, however, imposes her own restrictions in the form of an expanse of mud around the lake, which impedes foot travel, and in the inherent fear of humans she has given the birds. Sparse rainfall in recent years has caused the lake to recede as much as a thousand meters, creating a wide stretch

of solid terrain on which you can drive without fear of getting stuck. This makes it possible to use your car as a blind.

At sunrise, you are likely to be the only photographer on the lakeshore. The best shooting site is at the northern end, where the Njoro River trickles into the lake. Flamingos, pelicans, and other species congregate here in great numbers to drink and bath in the lake's only supply of fresh water. This is also the most likely place to find the park's white rhinos. Your arrival on the beach near the stream will create a temporary commotion among the birds (do not approach too closely or quickly), but if you sit still on the beach behind your tripod, the flocks will soon return and you can begin shooting. With a lens of 500 mm or longer, you can stay safely back from the birds, allowing them to conduct their affairs calmly while you make frame-filling images of their activities.

You can drive the dirt road that completely circles the lake, using your car as a blind to shoot the animals along the roadside. You will be able to shoot impala, warthog, waterbuck, and buffalo. The hippos at the north end of the lake must be shot on foot from the lake shore. They usually begin emerging from the lake to feed on lakeside vegetation about sunset and are quite wary of humans. Get into position early, remain motionless, and you should get good pictures.

OTHER ATTRACTIONS

Lake Bogoria, another alkaline lake 125 kilometers (75 miles) north of Nakuru, also boasts large numbers of greater and lesser flamingos, reportedly more than Nakuru at times. The lakeshore is lined with acacia trees which make excellent hunting

perches for the tawny and fish eagles that prey on the flamingos. This is one of the best places in Kenya to photograph greater kudu which venture to the lake to drink in the early morning. The lake is fed by hotsprings which throw masses of steam into the air, creating dramatic atmospheric settings in which the flamingos may be photographed. There is a beautiful, primitive campsite beside the lake near the hotsprings and a nice lodge (Lake Bogoria Hotel, reservations not needed) just outside the northern entrance to the park. You can enter the park as early as you wish and pay the fees on the way out.

Left: This Defassa water-buck was photographed from a vehicle in the early morning when many animals venture out of the forests to drink at the lake. Canon A2, 70-200 mm L Canon lens set at about 200 mm, Fujichrome Velvia, f/4 at 1/350 second. Below: This white rhino is one of several that graze on the grasses at the northern and western shores of the lake, often in sight of thousands of flamingos. The rhinos are docile and easy to approach.

Northern Gannets

Cape St. Mary's, Newfoundland
Late Spring / Summer

The grass topped cliffs at Cape St. Mary's provide nesting habitat for a variety of seabirds. The long view down to the ocean is filled with flying birds at every level. Caution is necessary when positioning the camera along the edge of the cliff which is slippery and slopes away steeply.

NORTHERN GANNETS ARE large, snow-white seabirds with light blue eyes, golden heads, and black-tipped wings spanning nearly two meters (six feet). Their crowded cliff-top colony at Cape St. Mary's on the Avalon Peninsula is the largest in North America. What sets this colony apart from other seabird rookeries is the magnificent setting atop Birdrock, a granite seastack that rises like a dark missile 108 meters (355 feet) from the cold north Atlantic. The pinnacle of the rock, crowded with gannet nests during the breeding season, is about 10 meters (33 feet) from the precipitous mainland cliffs from which photography is undertaken. The seas and skies surrounding the cliffs swirl with other species—black-legged kittiwakes, black guillemots, cormorants, razorbills, and murres.

The rolling landscape of the Avalon Peninsula, covered by tundra and stunted spruce forests, is home to caribou and moose. You should encounter both species on your drive to Cape St. Mary's. The cold seas around the peninsula are rich in krill and small fish called capelin, favorite foods of baleen whales such as the fin, minke, and humpback. Numerous whalewatching tour companies are located about the peninsula.

While any time during the summer is good for photography, early July provides the best opportunities for shooting seabirds, wildflowers, caribou, moose, and whales—all during one trip.

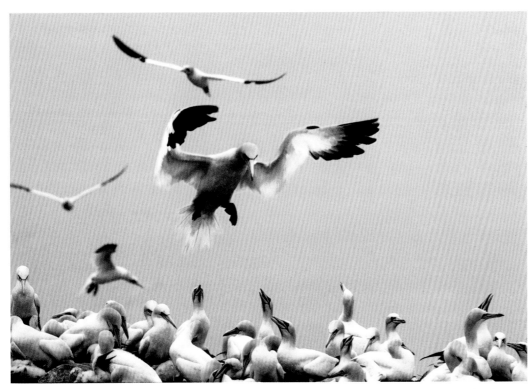

Left: For flight shots like this, you can train your lens on an interesting group of gannets, leaving ample room in the frame to record a bird coming in for a landing. You will not have to wait long. Canon T90, 300 mm L Canon lens, Fujichrome 200, f/11 at 1/250 second.

The weather is chilly, with lots of fog, mist, and occasional rain. Pack woolens and raingear. For more information contact the Newfoundland Department of Tourism (☎ 800 563 6353).

ACCESS AND ACCOMMODATION

You can reach the Avalon Peninsula by taking the ferry from North Sydney, Nova Scotia to Port-aux-Basques, Newfoundland, then driving 850 kilometers (500 miles) across the island. You can also go by ferry from North Sydney directly to the Avalon Peninsula. Both routes require about the same amount of travel time and reservations (☎ 800 341 7981) are necessary. You can fly into St. John's, the capital of Newfoundland, on either Air Canada (☎ 800 422 6232) or Canadian Airlines (☎ 800 426 7000) and rent a car for the two-hour drive to Cape St. Mary's (two-wheel drive is satisfactory). There are a number of motels and inns on the peninsula. The closest accommodation is in St. Brides (The Bird Island Motel, ☎ 709 337 2450), which is 13 kilometers (8 miles) from the gannet rookeries.

SHOOTING STRATEGIES

At Birdrock there is a concrete platform from which you can photograph the gannets. Because the skies are usually overcast, you needn't worry about being on site for sunrise or sunset. In fact, mid-day is preferable because the light will be strongest, allowing you to use faster shutter speeds. The gannets are active all day long—

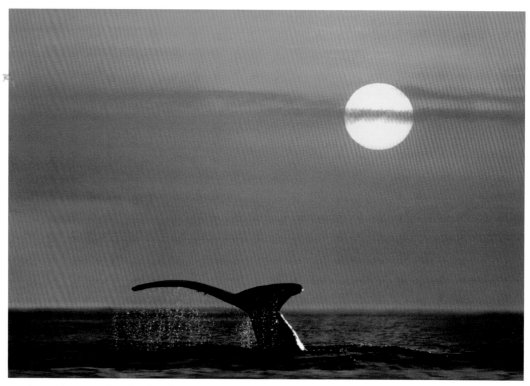

In this photograph of a humpback whale, a Cokin graduated neutral density filter was attached to the lens to darken the sky in the background and leave the remainder of the composition unaffected. Canon T90, 80-200 mm L Canon lens, 1.4X teleconverter, Fuji–chrome 100, maximum aperture at 1/250 second.

coming, going, courting, feeding the young, and engaging in territorial squabbles. Flight shots generally make the most impressive images. To do this, try framing an interesting portion of the colony, leaving an empty space in the composition to contain a flying bird. Watch the framed area and trip the shutter when a bird flies into your set-up. In 30 minutes you should be able to take a full roll of photographs. Lenses of 500 mm or longer and high contrast films of ISO 100 speed will be most useful.

Other Attractions

Moose and caribou are often found along the roadways and can be photographed from your vehicle or by a careful stalk over the tundra. Whale photography is excellent from a number of peninsula locations: St. John's, Portugal Bay, Foxtrap, Bay Bulls, Cape Royale, Tors Cove, Dildo, Trinity Bay, Witless Bay, and Placentia Bay. At Witless Bay, you can charter boats to take you cruising through the offshore island, an ecological reserve where millions of nesting seabirds, whales, and icebergs converge during the early summer. You are not allowed to land on the islands.

Appendix

Appendix

Nature Photography Guides and Periodicals

Art of Photographing Nature, Art Wolfe and Martha Hill, Crown Publishing Group, New York: 1993.

The Complete Guide to Wildlife Photography, Joe McDonald, Amphoto, New York: 1992.

How to Photograph Animals in the Wild, Leonard Lee Rue III and Len Rue Jr., Stackpole Books, Harrisburg, Pennsylvania: 1996.

Hummingbirds of North America: Attracting, Feeding and Photographing, Dan True, University of New Mexico Press, Albuquerque: 1993.

John Shaw's Closeups in Nature, John Shaw, Amphoto, New York: 1987.

John Shaw's Landscape Photography, John Shaw, Amphoto, New York: 1994.

Nature Photography: National Audubon Society Guide, Tim Fitzharris, Firefly Books, Willowdale, Ontario: 1996.

Nature's Best Photography Magazine, National Wildlife Federation, McLean, Virginia: quarterly.

Outdoor Photographer (magazine), Werner Publishing Corp., Los Angeles: monthly.

Photographing on Safari, Joe McDonald, Amphoto, New York: 1996.

The Sierra Club Guide to 35 mm Landscape Photography (New Edition), Tim Fitzharris, Sierra Club Books, San Francisco: 1996.

Wildbird Photography: National Audubon Society Guide, Tim Fitzharris, Firefly Books, Willowdale, Ontario: 1996.

Travel Guides

Adventuring in Belize, Eric Hoffman, Sierra Club Books, San Francisco: 1994.

Adventuring in Central America, David Rains Wallace, Sierra Club Books, San Francisco: 1995.

Adventuring in East Africa, Allen Bechky, Sierra Club Books, San Francisco: 1990.

Baja Handbook, Joe Cummings, Moon Publications, Chico, California: 1994.

Guide to Belize, Alex Bradbury, Bradt Publications, Bucks, England: 1994.

Honduras & Bay Islands Guide, Jean-Pierre Panet, Leah Hart, and Paul Glassman, Open Road Publishing, New York: 1996.

Lonely Planet Guide to Baja-California, 3rd ed., Wayne Bernarhdson and Scott Wayne, Lonely Planet, Berkely, California: 1994.

Lonely Planet Guide to Canada, Mark Lightbody, Dorinda Talbot, and Jim DuFresne, Lonely Planet, Berkely, California: 1994.

Lonely Planet Guide to East Africa, 3rd ed., Geoff Crowther, Lonely Planet, Berkely, California: 1996.

Lonely Planet Guide to Mexico, 5th ed., Wayne Bernarhdson and Tom Brosnahan, Lonely Planet, Berkely, California: 1995.

Mexico Handbook, Joe Cummings and Chicki Mallan, Moon Publications, Chico, California: 1996.

The Sierra Club Guides to the National Parks of the Desert Southwest, Stewart, Tabori & Chang, Inc., New York: 1984.

The Sierra Club Guides to the National Parks of the East and Middle West, Stewart, Tabori & Chang, Inc., New York: 1986.

The Sierra Club Guides to the National Parks of the Pacific Northwest and Alaska, Stewart, Tabori & Chang, Inc., New York: 1985.

The Sierra Club Guides to the National Parks of the Rocky Mountains and the Great Plains, Stewart, Tabori & Chang, Inc., New York: 1984.

Spectrum Guide to African Wildlife Safaris, Camerapix, Facts on File, New York: 1989.

The Travelling Birder: 20 Five-Star Birding Vacations, Clive Goodwin, Doubleday Dell Publishing Group, Inc., New York: 1991.

Field Guides

Birds of Kenya, Dave Richards, Hamish Hamilton Ltd., London: 1991.

A Field Guide to the Birds of East Africa, John G. Williams and Norman Arlott, William Collins Sons & Co. Ltd., London: 1986.

A Field Guide to the Birds of Mexico, Ernest P. Edwards, E. P. Edwards, Sweet Briar, Virginia: 1972.

Field Guide to the Birds of North America, 2nd ed., National Geographic Society, Washington, DC: 1987.

A Field Guide to Mexican Birds and Adjacent Central America, Roger Tory Peterson and Edward L. Chalif, Houghton Mifflin, Boston: 1973.

A Field Guide to the National Parks of East Africa, John G. Williams, William Collins Sons & Co. Ltd., London: 1986.

The Peterson Field Guide Series: A Field Guide to the Mammals, 3rd ed., William H. Burt and Richard P. Grossenheider, Houghton Mifflin Co., Boston: 1976.

Travel Photography Newsletters

Photograph America Newsletter, 1333 Monte Maria Avenue, Novato, California 94947 (☎ 415 898 3736).

Photo Traveler, P.O. Box 39912, Los Angeles, California 90039 (☎ 800 417 4680).

Bobcat, Montana

PRODUCED BY TERRAPIN BOOKS
Santa Fe, New Mexico